THE PROBLEMS IN
THE ART WORLD

AN ARTIST'S
A-Z ACTION GUIDE

BRAINARD CAREY

ALLWORTH PRESS
NEW YORK

Allworth Press books may be purchased in bulk at special discounts for sales promotion, corporate gifts, fund-raising, or educational purposes. Special editions can also be created to specifications. For details, contact the Special Sales Department, Allworth Press, 307 West 36th Street, 11th Floor, New York, NY 10018 or info@skyhorsepublishing.com.

28 27 26 25 24 5 4 3 2 1

Published by Allworth Press, an imprint of Skyhorse Publishing, Inc., 307 West 36th Street, 11th Floor, New York, NY 10018. Allworth Press® is a registered trademark of Skyhorse Publishing, Inc.®, a Delaware corporation.

www.allworth.com

Cover design by Mary Ann Smith

Library of Congress Cataloging-in-Publication Data is available on file.

Print ISBN: 978-1-62153-795-3
eBook ISBN: 978-1-62153-796-0

Printed in the United States of America

Contents

Introduction

HOW TO USE THIS BOOK FOR CAREER CHOICES AND PROBLEMS

This is the seventh book I've written for artists and the first one to address the "problems" that so many artists speak about in different ways.

There are many problems, but they often revolve around similar issues—getting work sold through a gallery, getting an email answered, and getting contacts and introductions to people that can help you.

Besides those immediate problems, there is also the problem of fairness, so to speak. Is it all about who you know? If you were dating a powerful figure in the art world, would that give you an advantage? Some of these questions are troubling and take patience to tackle.

I have interviewed over 1,900 artists for Yale University radio and much of my knowledge base and information comes from those interviews. Artists shared problems in my interviews and the answers they have found—and the artists in those interviews are from all over the world.

In this concise action guide, I will go over the issues and provide the perspective I have heard from artists of all types from photographers and painters to installation artists. The format is designed so you can open the book to any page and see actions to take, in a concise manner. When necessary, there is additional information in the appendix. For those readers new to the art world, there is a concise guide to the art world "ecosystem" terms that is also at the very end of the appendix, the last pages of this book.

THIS MOMENT IN HISTORY

We are living in times of great luxury spending coupled with extremism in many forms. The post-pandemic art world is awash with money to purchase art like never before. Art fairs are multiplying all over the world. New York City alone has more than 1,400 galleries—that's not a typo: more than one thousand, four hundred galleries—at the time of this book's writing. That is largely because some of the wealthiest people in the world got even wealthier after the pandemic due to investments they made. That elite and large group needed a place to put their money, and one area is the luxury market. Art has always been part of that market, but not on the scale it is now. Now we have billionaires looking to buy work that may increase in value as part of their financial plan.

On a practical level, not a political level, this is good for some artists. Late capitalism has many inequities, and one is that the very rich are buying art at a very fast pace.

Even if your art is not for sale or in the marketplace—in performance or installations, etc.—this may affect you, because visual art that is not for sale contributes to the art ecosystem in this financial environment through nonprofit institutions (like museums), which we will discuss.

The problem with this situation is that it is not clear how to get your work in front of those buyers, if your goal is to sell more of your art. Can these buyers even be reached?

This book is designed to answer that question and several other problems that concern the worldwide marketplace for your art as well as the local and regional marketplaces.

PROBLEMS

I have asked artists over and over what their biggest hurdles and their biggest art problems are, and I hear consistent answers. It is getting representation at a gallery, it is getting emails answered by a gallery, and it is also knowing what the next steps are to make that process as clear as applying for a job—which it is not.

The art world is not known for clarity or transparency. At least not at the moment.

The biggest problem with the idea of participating in the art world is that there is not one Art World, but many. Here are just five different art world models for artists, though there are many more:

1. There is the world of billionaires buying in the first hour of a major art fair to get what they are told is the "best" work.
2. There is having one or more local galleries sell your art, to the point of making a living—not getting reviews anywhere, yet surviving off your art.
3. There is an online art world, where artists set themselves up as a business and use all the marketing tools the internet allows to sell art.
4. There is the nonprofit art world, where you can apply to exhibits (without an entrance fee) and get your work seen, potentially all over the world, but rarely sold. In that model, you meet more people and sell less but have a good time sharing your art.
5. There is also the model that is a hybrid of some of these or something new altogether. In this book I will break down those worlds and the problems and solutions needed to get a foothold in a series of suggested actions.

Note: This book is designed to be a quick reference that will guide you to take action. Each of the twenty-six problems are reduced to a brief text and a specific action that you can read more about in the back of the book. Once you understand the elements of building a career in the arts, you can check in here to see how to put these actions in order. In other words, this is not a book of theory, it is a series of suggested actions to take—as simple as posting pages of this book on Instagram or your refrigerator (which is how they become a reality) and putting your actions and ideas literally out into the world.

If you want to meet me or my team to have a look at your art, almost all the pages of this book, especially the right-hand pages, are meant to be shared on Instagram or whatever social media you are using.

So, if you want to connect, share an image of something you like or an action you are taking and I may repost it on my story and look at your art.

—Brainard Carey

www.instagram.com/praxiscenterforlearning/

PROBLEMS AND ACTIONS

THE PROBLEM OF COMMITMENT

On the one hand, you are a committed artist. That is not up for debate. Even if you are not making art at the moment, you are most likely an artist if you are reading this.

On the other hand, if you want to accelerate the rate at which you are sharing and selling your art, you must commit to the process of that even if it is not pleasant.

If you want to keep making art and learning from this book, state your commitment publicly now by taking a picture of the opposite page and tagging me so I can see and read your commitment and so I can also see your art.

Public declaration:

I am a committed artist, period.
I am doing what it takes to get
my work out there.

Thank you for your support.

"You may never know what results come
from your actions, but if you do nothing,
there will be no results."
—Mahatma Gandhi

@praxiscenterforlearning

THE PROBLEM OF GETTING RECOGNITION

We all want to be seen and heard—whether you are an artist or not.

For artists, being seen is critical to the art itself existing. Art must be exhibited, it must be seen in some way to give the artists that satisfaction of recognition, of being *seen* in the largest sense of the word.

If you are not getting enough exhibits, whether of the kind you used to get or if you have not exhibited much at all, there are several steps you can take to get back on track.

An exhibition can happen almost anywhere. A gallery that sells art is good, but there are so many more places that will get you seen and heard which can then lead to more gallery interest.

Consider making a pop-up style exhibit* for one night only. It could be in your home, apartment, or a friend's apartment, home, or garage.

Just for one evening.

Invite friends and family to a showing of your work, you can give a brief talk if you want, and that is all. Sales may happen, but the goal is for the work to be seen.

Complete this by posting and tagging the opposite page, and your art will be seen by myself and all my Instagram followers.

*See Appendix entry 1 for more information on creating a pop-up.

I am an artist.
I am planning an exhibit.
In a secret space . . .
. . . to be announced.
Stay tuned.
You will be invited.

@praxiscenterforlearning

THE PROBLEM OF A COMMUNITY (OR LACK OF ONE)

As an artist, you can and should be supported by your community* of artists, collectors, curators, and others who make up what we call the art world. You know this instinctively, but the process to find and enter that community is not clear.

The difficulty of this is that an artist can become isolated without a community and then the work itself can be harder to get out into the world.

There are several ways to find a community. One is through residencies, which you can apply to for free, and there is more information in the appendix** on resources for that.

Another way is to build your own community by putting together a show of a few local artists in real life, maybe just for one night at a bar, a friend's house, or somewhere else inventive, and see where that goes.

Becoming a bystander, an onlooker only, at gallery openings and events is a way of watching the community, which can be enjoyed with or without engaging people.

For the action on the next page, which is about starting a relationship with one person at a time, send a compliment that is detailed without giving them your website or asking a question.

*See Appendix entry 2 for more information on communities.
**See Appendix entry 16 for more information on residencies.

I am writing a beautiful letter
And sending it out to a person
I admire, to plant seeds,
to grow into a living community
Because artists need a community

@praxiscenterforlearning

THE PROBLEM WITH GRANTS (AND GETTING ONE)

Grants are literally free money for artists, but the catch is that you must apply for them. That presents the problem of how to write them, what to write about, and how to find the grants in the first place. But as difficult as that process might be, and though rejection is part of the process, the prospect of winning a grant is very likely if—big IF—you write enough of them.

How many should you write? I would consider a minimum of six and a max of twelve to fifteen grant applications per year. If you do that, you will know about as much as there is to know about grants.

Sometimes it's hard to know if you are the right fit for the grant or if you really have a chance of getting it, and the best way to answer those questions is to ask. The person to ask is the one who answers the email for the granting foundation. It's that simple: ask the grant foundation if you are a good candidate. They always want to help people make better applications.

The other problem is where to find these grants! You can research online, or even your local library (librarians can be helpful and kind). I have also compiled a list of grants on my blog which I update regularly.

Use the action item on the next page—photograph or screenshot it and share it on Instagram, and that will help you commit. You might get feedback from friends or from me. :)

*See Appendix entry 3 for more information on grants.

I am working on applying
for a grant, but first I am
doing research, just
wanted to put it out there.

Anyone else apply for a
grant lately?

@praxiscenterforlearning

THE PROBLEM WITH MONEY (AND THE LACK OF IT)

Sobering fact: Some of the biggest artists I have interviewed for Yale University radio, who even have major galleries representing them, also have a day job like teaching or something else.*

Why? Because even if you have a big gallery behind you, the income is not dependable in most cases, and a second job takes the pressure off your art.

The stress of being strapped for cash or nearly broke can affect your art, so consider a job that is not soul-sucking, so you can come home and make art in peace.

Share the next page as an image on Instagram, or make it the wallpaper on your phone because putting it out there helps to make it happen.

*See Appendix entry 4 for more information on income streams.

I am looking for an
income, a job, that
will support my art
making, not drain me.
Something like being
an assistant to an artist
or perhaps teaching.
Any leads out there?

@praxiscenterforlearning

THE OPPORTUNITIES PROBLEM

We all need more opportunities, more chances, more connections, more possibilities. That means opportunities to exhibit, opportunities to sell, opportunities to meet other artists and curators.

Where to find these opportunities? No matter where you live, there are solutions to this problem. You can begin with your local council on the arts in the United States. In Europe and elsewhere, it is usually called your local Ministry of Culture or similar.

There are also numerous resources for international residencies, grants, artist-run spaces, and more online.

All the traditional sources and links to explore are in the Appendix,* but then there are other types of opportunities—like the ones you make yourself. Like having an exhibit in your apartment, or getting together with friends to start a collective, or creating visibility through public performances or even chalk drawings on the street.

The only caveat—never pay for a show! Or almost never: those types of shows don't get the visibility they should, because the organizers are making money from entrance fees.

The opposite page is a good way to connect with other artists on Instagram by taking a picture and sharing it. Tag me, and I will see it.

*See Appendix entry 5 for more information on opportunities for artists, councils on the arts, and ministries of culture.

I am always looking for new opportunities as an Artist, and I am putting it out into the world. Do you know of any open calls for artists or other opportunities?

@praxiscenterforlearning

THE SCAM PROBLEM

Unfortunately, there seems to be no shortage of scams out there for artists. In the past few years the latest scam is an Instagram DM asking to sell your art as NFTs, which is just a way to get you to pay the fake buyer a fake "gas" fee that results in nothing but money lost.*

There are also numerous gallery exhibition scams—which ends up meaning that you pay to be "represented" or shown by that gallery. Even if you pay the hefty fees, you will very likely not make a sale because the gallery is making money off renting walls to artists.

In general, never pay for a show or a competition. Occasionally there are exceptions to this rule with small entry fees, but I would avoid those too.

For a list of the many scams that artists deal with, you can go to this website, which is all artist-submitted information on scams from galleries, agents, and much more: howsmydealing.com.

Use the post on the opposite page to build a community of artists on Instagram by letting each other know about scams.

*See Appendix entry 6 for more information on scams and pay-to-play situations to avoid.

Any artists here have experience with scams that try to take your money?

THE SOCIAL MEDIA PROBLEM

Endless posting on Instagram and more is a big problem because it is time consuming and also, we are told, it is needed.

But is it really needed?*

There are artists who have galleries and are successful and do little or nothing on Instagram and elsewhere.

If you like Instagram (and I do), then have at it. But if you feel like it is a waste of time, then don't use it. It is not about your career, because you can't build a career on Instagram. You can get comments and attention, and that is valuable since you want your art to be seen and understood, but for sales on Instagram, you will have to work very hard.

By "work very hard," I mean you should have an Instagram store and a squarespace or shopify website, and follow people who do the same, so you can see how they sell and market prints and original work.

The easiest way to sell art is through a gallery. It takes time, but a relationship with a gallery or several galleries will yield sales in most cases, with much less social media posting effort on your part.

So if you enjoy Instagram, then keep using it, and if you don't, then stop.

If you want me to see your Instagram, take a picture of the next page and tag me.

*See Appendix entry 7 for more information on social media tactics.

I have been making more art
lately. Have you seen it?

If you check it out and
comment, I'll do the same
for you.

@praxiscenterforlearning

THE PATRON PROBLEM

The difficulty with being an artist is often money, and historically, from the Renaissance and earlier, there were patrons of the arts that helped artists fund their studio and work.

The good news is there are more patrons than ever in the art world today.

The bad news is that it isn't always easy to find them!*

So what is an artist to do?

The first course I started teaching at Praxis Center was one on writing to patrons and sponsors and getting their support. I helped artists write letters and reach out, so I have seen how they were successful down to every word used and how much money came in.

Where do you find art patrons?

They are all listed publicly—they are on the boards of the museums near you, they are the trustees of the museums near you, and they comprise that giant list of donors you see on the art museum website.

How do you find their contact information? You search their names online and you will likely see a "foundation" associated with that name.

You can do all that and/or start with a post about your intentions by writing something yourself or taking a screenshot of the opposite page and sharing it on Instagram and tagging me. Let me know what happened by sending me a direct message on Instagram.

*See Appendix entry 8 for more information on patrons and sponsors.

I am an artist in need
of a patron to
support my dream.

Have you ever
invested in a dream?

DM me if you are
interested.

THE NETWORKING PROBLEM

Almost nobody likes to network, especially in person. If that is you, then how do you get yourself to do it?*

My suggestion is to begin by going to gallery openings and try not to talk to anyone—that's right, be silent and just look around. This will take the pressure off you. It will also be helpful to see what is going on, and it will put you in a place of power.

Try doing that several times, and then if you want to talk, do so. Otherwise, wait until someone approaches you. I know this may sound crazy, but it is a safe way to put yourself out there and not pressure yourself to chat with everyone. Try it and see what happens.

Take a photo of the opposite page to remind you of this and keep it on your phone where you will see it or write it on a piece of paper where you will see it daily.

*See Appendix entry 9 for more information on networking.

I go to galleries
more and more, and
I am networking by
Watching and listening
for as long as I want,
not talking.

@praxiscenterforlearning

THE ONLINE SALES PROBLEM

How do you make sales online? This is a question I hear a lot.*

There are many ways, but here is a simple way. It will take time to set up, but it is straightforward.

1. Start an Instagram shop and sell through there, or link Instagram to another website for sales.
2. The best and cheapest website I know for sales is squarespace.
3. Observe the many other people on Instagram who have Instagram shops and how they market their work.

Use the opposite page to meet other artists who are doing the same to learn from them.

Just take a picture of the page and share it on Instagram.

*See Appendix entry 10 for more information on sales.

Instagram art sales?

Who is doing it out
there?

I want to see
some good examples
of artists who are
doing it well.

@praxiscenterforlearning

THE FUNNEL PROBLEM

What is a funnel? It is the sales format everyone uses online! The problem is that most people have no idea what a funnel is and how to make one.

The truth is that it is fairly simple, and while there is more on this in the Appendix*, here is what it consists of.

1. Lead magnet (a specific ad or post)
2. Viewer clicks and enters their email or other form of contacting them through the ad or post lead magnet).
3. The viewer is retargeted (sent) info on your work and how to buy it.
4. The viewer continues to receive pre-written automated newsletters and ads.
5. Purchase is made easily with no more than three clicks through a newsletter or ad.

Share the opposite page as a first funnel step (a free lead magnet).

*See Appendix entry 11 for more information on funnels.

I am starting a
newsletter about my art, and
if you want to hear what's
happening in my studio just
comment:

Yes!

and I will message you.

THE ADVERTISING PROBLEM

As soon as a funnel is started (see action L), the question is always when to advertise* by boosting or putting money behind an Instagram post.

It is best to first start with free options, like asking if people want your newsletter. But you could also give something away as a lead magnet like an inexpensive print, or a downloadable book of your art, or a zine.

When one of those posts seems a little popular, several people get it, and you make one sale, then you can begin to advertise.

So, begin with trial and error until one of your posts on Instagram, for example, gets engagement of likes or comments and eventually a sale. Then put a small amount of money behind it to see if it works over the course of a few days. Maybe 10 dollars or 10 euros a day for a few days only—by "boosting" it on Instagram, for example.

If it works, you can increase the amount spent until you make another sale through your funnel.

*See Appendix entry 12 for more information on advertising online.

Action: Boost your most
popular Instagram post for
$30 or €30 over three days,
if you can afford it—

and then
look at the "insights" from
Instagram afterward
and analyze that.

THE ARTIST STATEMENT PROBLEM

This is one of the more frustrating aspects of applying to anything—an artist "statement."*

You're an artist, not a writer, correct?

So if you must write this, here is a thought.

Write something genuine, write something from the heart, or write a question you have or a poem, or a fragment of text, or leave it blank or write that you do not write artist statements because you are a visual artist!

I think that last suggestion is the most liberating and, yes, a bit radical for a career-minded book. But you are an artist, let's break the rules!

When an application asks for an artist statement, or on your website and anywhere else an "artist statement" by you might appear, in place of that write exactly this: I do not write "statements," as I am a visual artist.

I think that makes it clear, and maybe we can change the world this way. If this goes viral and artists all over the world start writing on applications that they "do not write artists statements," a social movement could take place that will make curators, gallery owners, and administrators think twice about why they ask artists for "statements." And perhaps like so many trends and social shifts, we can eliminate the need for the artist statement. Revolt!

You can start by sharing a post (can it go viral?) like the one on the opposite page on Instagram or any version of it if you like.

*See Appendix entry 13 for more information on composing your artist statement and biography.

What is your artist statement?

I am thinking of going on
an "artist statement" strike,
because I am a visual artist,
and I don't want to put my
art into words.

Any thoughts on this?

@praxiscenterforlearning

THE MENTOR PROBLEM

As an artist, no matter what stage you are in, beginner, mid career or mature career, a mentor of some kind is often helpful when applying for grants or negotiating with a gallery. Where do you find these mentors?*

There are classes, there is the university setting, and there are fellow artists, as well as people like me who write books and teach online classes.

To find a good one, you can ask other artists, and then I would rely on your gut—on your instincts and intuition.

Does the person who you are considering to be your mentor have an approachable and sincere manner? Do you feel comfortable with them? Is the information they put out into the world helpful?

Put the note on the next page in a bottle by posting a photo of it on Instagram.

*See Appendix entry 14 for more information on finding a mentor.

Looking for an art mentor . . .

Any suggestions?

THE RESIDENCIES PROBLEM

Understanding what to use an "art residency" for is often a problem. A residency is a way to have a studio outside your home, in another country in many cases, with all your expenses paid.

However, it isn't a vacation, though it might sound that way. It also requires an application and is competitive.*

What you will find at a residency is several other artists and curators that are interested in looking at art and talking and enjoying good meals together. It is a chance for you to make art of your choice in a studio where you have your own space. It can be blissful and productive or uncomfortable and not productive, it depends on the residency.

If you want to be sure you get at least two residencies a year, any year you want, fully paid with a stipend so you don't spend a dime, I would suggest you apply to about twenty good residencies from all over the world—twice a year, in the fall and spring when the deadlines occur. So that's a nearly superhuman forty applications a year, but it will literally make you an expert at these applications, and you will win some and enjoy yourself in another country. You can apply to fewer, of course, but submitting that number of applications will keep you in residencies nearly year-round.

If you can afford it, you can also hire someone to help you do it all.

The action here is simply internet research.

*See Appendix entry 15 for more information on residencies.

Action:

Research art residencies and
if you want to ace this and be
nearly guaranteed at least two
paid residencies a year,
then make a heroic effort,
apply for about twenty
twice a year.

The deadlines tend to
be in the fall and the spring.

@praxiscenterforlearning

THE SELF-WORTH PROBLEM

This is the most difficult problem and the one that gets in the way of all the others!

Is your art good enough? Are trends in the art world passing you by because you are not "on trend"?

History tells us that all those external concerns for artists always lead in the wrong direction.

It is not about if your art is good enough, because we know that art that was considered "bad" in one decade can be "genius" the next. So, what is it about? Is there a standard to measure yourself against?

Art breaks all the rules here. Make what you want, when you want, however you want. You are the artist, and you make the rules.*

If something else is holding you back—something personal, like a trauma—I would suggest you seek therapy or use free chatbot therapists. Take what works and leave the rest.

Photograph and share the next page or put it on your fridge.

*See Appendix entry 16 for more information on self-worth issues.

"I am the measure of my worth,
and I say I am worthy."

—Mathilde Blind

@praxiscenterforlearning

THE WORK-LIFE BALANCE PROBLEM

There is always the issue of how much to do all the "business" and networking stuff . . .

That is a big problem. How many of the actions in this book do you need or even want to do?

If you are in your studio regularly and are also filling out applications and updating your website and Instagram, when do you have time to dance?

When do you get to just play and relax with family, pets, or even alone?

"All work and no play makes Jack a dull boy," as the proverb goes—and is also associated with horror because of the Stanley Kubrick film *The Shining.*

I would suggest having as much fun as possible, make that the priority, because it will add to your time making art, and your art will exude some of the joy you have in your life.

That could mean literally more play, or more reading, or more laughing with a funny movie . . .

Proposed work/life ratio:

75 percent studio (making art, related activities, and other income-generating activities)

25 percent play (anything from meditation to dancing to reading)

If you shoot for that ratio you might end up at 70 and 30 percent and that too will bring more joy to the world. Shoot for the stars . . .

Share the next page on Instagram and tag me, it will make my day.

Today
I am
going
out to
play

THE STUDIO PROBLEM

You need a studio and you don't have one or it's too small . . .

The problem is usually the extra rent on a bigger studio* and there are a few ways to solve.

You could clear out a room in your apartment or house, even your bedroom, and sleep in the living room until you get a bigger studio.

You can sometimes time-share a studio in a private studio space in your area. That means instead of splitting the rent with someone, you rent it by the day and bring most of your supplies in and out in two or more days a week. You commit to a certain number of days per month in that arrangement.

You can apply for residencies and get a free, temporary, all-expenses paid studio! (See action P.)

You can use a room in your house in a similar way: clear it out for a studio a few days a week and then put it back the way it was.

If you have the money, rent a warehouse space or space in a "studio building" in your area, if available. That will be the most luxurious setup at the cheapest price in most cases—if you want an external studio that is your own in a secure and safe building you can always access.

Ask friends, relatives, or fellow workers nearby if they have any extra non-living space they could rent cheap, like a garage.

Post the opposite page on Instagram to see what turns up or check local listings online.

*See Appendix entry 17 for more information on studio visits.

Anyone have an
Extra non-living
Workspace to rent?

Garage or room?

I need more room to
make art!

DM me, please, if you have leads.

THE STUDIO VISIT PROBLEM

Once you have a studio, how do you get people to visit your studio and what do you do once they are there?

If you haven't had many studio visitors or are showing your art off your kitchen table, start with family and close friends, tell them you are practicing a studio visit.*

You can do it with Zoom or, ideally, in person, but both are good ways to practice what you will say and do.

There is more writing in the Appendix* about this, but be brave, show your work, and you will get better at it and receive a lot of love. It's really a simple show-and-tell experience.

Trading studio visits with other artists by Zoom or in person is also a fun way to practice and make friends.

Use the opposite page to trade visits through Instagram or Zoom.

*See Appendix entry 17 for more information on conducting studio visits.

Anyone want
to trade studio
visits through
Zoom?

Message me if
interested.

THE WRITING PROBLEM

Artists make images, they don't write . . . Why must you write as an artist? Why is this a requirement for career advancement?

Well, my thought is that because we are all using language as our main form of communication, and visual artwork of almost all types is somewhat mystifying, the non-art-making public wants words.*

With words the viewer can sometimes enter the artist studio and feel part of a magical world they really didn't know existed, because no one ever talked to them about art or showed them art. I think most of the public is like that. They need an entry point to understand art. Part of that is lack of art education; they did not grow up in a home that was visually literate, or a home or school that taught art appreciation. Thus, words!

There is much more writing on how to get around this sticky subject, but the long and short of it is this: Collaborate with a writer. Hire them if possible, but work with someone who can help you write so that your writing will feel like you are walking the reader through your studio or at least allowing the reader an insight of some kind.

Hint: Everyone is using ChatGPT to help them write. Try asking ChatGPT to write about art, or to write a blog post about your art and see what happens. Caution: Automated writing can sound cold, so be sure to edit it thoroughly.

Take the action on the next page by taking a photograph or tagging and show the answer you received. Or do it privately, of course.

*See Appendix entry 18 for more information on writing.

I asked ChatGPT to do a task:

Write a rave review about
my art in approximately
500 words

This is the answer I
received . . .

@praxiscenterforlearning

THE PROBLEM OF MANNERS

Manners?

What is the etiquette of writing, calling, etc.—what is professional? What is bad form?*

Letter-writing conventions for email can start with "Hi," or even nothing at all, just straight to the message. I almost always start with Dear [name], and while that may sound dated, which it is, I think it also shows respect. Many people begin writing back to me that same way after seeing me do it a number of times, but that is one important element of style and first impression. You can do it any way you like, but it is important, so consistency counts.

What is professional is being straight to the point and following up.

If you don't hear from someone, keep sending the same letter every week, more or less, until they answer. That is a professional technique if you are following up for an interview or possible interest.

The notion is that you deserve an answer. It is an unwritten rule in a way. We all want closure, though some avoid it. Seek closure, for your own sanity. Get an answer. Just be polite and you will not burn any bridges. Instead you will be respected for your passion and follow-through.

That's the short of it!

The next action page is something to do at your own pace and then tag me, and I will cheer you on!

*See Appendix entry 8 for more information on manners and etiquette.

Write a thank-you
note to someone—
a professional or
personal contact,
even a company.

Do it five times
with five
different people.

If you get a response,
let me know.

@praxiscenterforlearning

THE RESOURCES PROBLEM

Where do artists get the best resources for good opportunities of instead of scams?

You have probably noticed there is no shortage of scams, like direct messages asking to make your art an NFT, or a fraudulent interest in a sale, the exact opposite of an opportunity.

It is a problem for artists.

What you want to look for is this: "no fee" opportunities for exhibitions, awards, grants, residencies, and almost anything else.

Don't pay a fee unless it is one time only, for a very small amount.

Wherever you are in the world, look for local art resources, which will provide lists of even more resources. Check your local ministry of culture or arts council or just do a search for that near you. That way you can cut through all the scams online and often meet real people at local supportive centers for artists. They exist! They are often funded by the government or local patrons, because it is about education and cultural growth.*

I write a blog and have updated resources there, but your local search will yield something you can physically go to and is also a good way to meet your community and make friends.

*See Appendix entry 20 for more information on international resources.

Action:

Find three resources and
write down
six opportunities that you
don't have to pay for.

THE PRICING PROBLEM

How to price your work? This is a problem for new artists and even mid-career artists when working on something different from previous work.

Setting a price for your work is based on a few things, at least:

1. Previous sale prices
2. The way the work is brought to market and sold
3. The scope and size of the work

Other methods price by the square inch or centimeter, but those methods are not often reliable, especially when the work isn't painting. Do you price sculpture by the pound? No, that's silly—so why do the same with paintings?

If you have ever sold anything before, use the last sale as a starting point. Your price should be 20 percent higher than that. Then raise it at least 10 percent every time something is sold, or twice a year, more or less.

If you have never sold anything, start with at least the cost of materials then keep raising it every time your artwork is sold by at least 10 percent.*

Trust your instincts, but don't price things out of your market by pricing something at $10,000 when you have sold only several works at $1,000. On the other hand, don't make it so inexpensive that the buyer has to wonder why it costs so little.

That is the "CliffsNotes" on pricing. If you are working with a gallery, they will tell you what they have sold work for in the past, which will also help to price yours.

*See Appendix entry 21 for more information on pricing your art.

Set prices on at least a dozen
works of art you own.

Set prices assuming a
gallery is taking 50 percent of a sale.

Put those prices down on
a page with images of the
art next to them.

Then after that, write another
price list, and double all the
prices and print it out.

Then after that, write another
price list, and triple all the
prices and print it out.

Look them over and see
which one makes sense to you.

Use the one you like for
this year's prices.

@praxiscenterforlearning

THE QUALITY AND VALUE PROBLEM

How do you know your lack of great exhibits isn't because your art just isn't good enough?

This may seem like a practical question, and it is, but of course it is also a deeply personal one* and completely subjective.

There truly is not an objective standard to what is good art.

Even in a university setting, your art would not be evaluated for its level of accomplishment or technique, it would be evaluated on how well your message was conveyed.

That is why college art students learn to "defend" their work, to push back on detractors and explain their intentions.

That is the state of contemporary art.

If you are trying to learn a specific technique, like types of portraiture or a specific type of landscape painting, then yes, there are levels of success in terms of technical skill level. But if your work is not within a very specific tradition, then there are no rules for you—just express what you want, in any way you wish.

Post the next action on your fridge or share it.

*See Appendix entry 22 for more on self-worth tactics.

I am enough
My art is enough

I can make
whatever I wish

I make the rules

@praxiscenterforlearning

Z
THE PROBLEM OF MORE PROBLEMS!

The list will continually grow because there are many **Art Problems!**

What are yours?

What Art Problem do you want addressed?

Tag me using the next page and let me know of any Art Problem you want addressed.

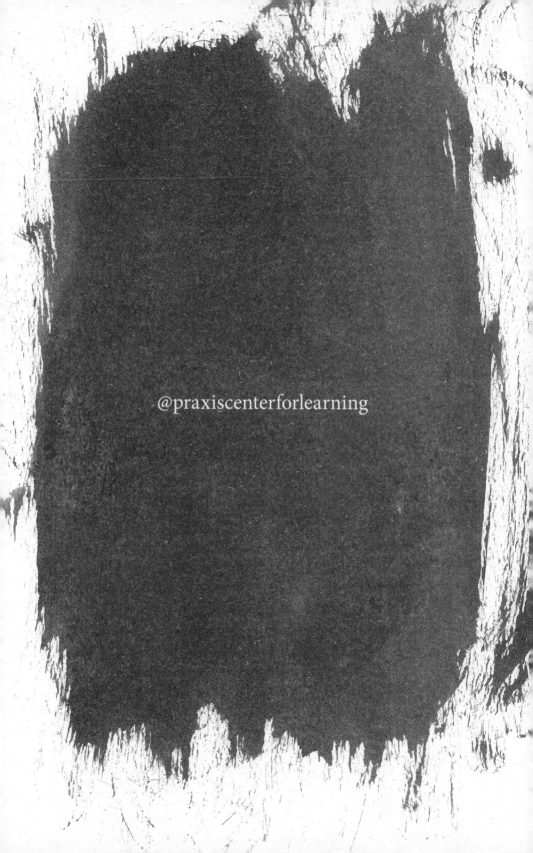

APPENDIX

1.

MORE INFORMATION ON HOW TO MOUNT YOUR OWN EXHIBIT WITHOUT A GALLERY

Mounting your own art exhibit without a traditional gallery can be a rewarding and creative endeavor. It allows you to have control over the presentation of your work and to engage directly with your audience.

Here is a list of ideas with more detailed advice.

Conceptualize Your Exhibit
Decide on the theme, concept, or narrative that will tie your artworks together.

Consider the story you want to convey and how you want the audience to experience your art.

Select and Prepare Your Artworks
Choose a selection of artworks that fit the theme and tell a cohesive story.

Ensure that your artworks are properly framed, mounted, and ready for display.

Find a Suitable Venue
Look for alternative spaces such as community centers, cafés, libraries, co-working spaces, or even your own home.

Consider the size of the space, lighting, accessibility, and overall vibe.

Plan the Layout
Create a layout design that optimizes the flow of the exhibit and enhances the viewer's experience.

Determine the placement of each artwork, considering factors like spacing, height, and visual look.

Promotion and Marketing

Develop a marketing plan to promote your exhibit. Utilize social media, email newsletters, and local event listings.

Create eye-catching promotional materials such as posters, flyers, and digital graphics.

Write a compelling exhibition description to accompany your artworks.

Opening Reception

Organize an opening reception to introduce your exhibit to the public.

Consider providing refreshments, music, or live demonstrations to create a festive atmosphere.

Be prepared to engage with visitors, answer questions, and discuss your art.

Documentation

Take high-quality photographs of your artworks before and during the exhibit for documentation and future promotion.

Pricing and Sales

Clearly label each artwork with its title, medium, dimensions, and have prices on a separate list (if you're interested in selling).

Have a system in place for handling sales, such as mobile payment options or an on-site sales desk.

Engage with the Audience

Offer artist talks, workshops, or demonstrations during the exhibit's run to engage with your audience and share insights about your creative process.

Feedback and Follow-up

Encourage visitors to provide feedback in a guestbook or through digital platforms. Follow up with attendees through email or social media to express gratitude and keep them informed about your future projects.

Reflect on the experience after the exhibit concludes. Consider what worked well and what you would do differently next time.

Remember, mounting your own exhibit requires careful planning, dedication, and hard work. While it may be more challenging than exhibiting in a traditional gallery, it offers you the opportunity to showcase your art on your terms and connect with your audience in a more personal way.

Mounting Your Own Pop-up Show

There is also a burgeoning DIY movement in the art world now. Generally it means that now many artists are "doing it themselves"; that is, they are working outside the gallery system. They are bypassing the traditional intermediary in the equation and working directly with the public. That notion pertains to visual artists, musicians, writers, dancers, and many others in the arts.

Marketing Your Pop-up: *For the Love of God*

Damien Hirst, who is loved and hated by artists for his sheer success, has created ways to sell art that are worth attention.

He has sold outside of his gallery for greater financial gain and control, but it also is instructive in terms of how one artist created elaborate pop-ups that received global attention.

He created a now-famous work of a skull covered with diamonds called *For the Love of God*. He said it would be the most expensive artwork ever sold. He thought it would sell for about $100 million. He received tremendous worldwide press for saying he would try to sell it for that much. It is an age-old marketing technique of announcing you are going to break a record of some kind to generate press attention.

In fact, he never sold the skull for $100 million, but he had a very savvy backup plan. He put together a group of investors, of which he was one investor, and sold the work for $76 million dollars to the group.

Hirst is often criticized as a model of excess and market manipulation, and he may deserve that, but he is also offering new ways for living artists to make much more money off their work than anyone previously thought possible. He ushered in a new era where the marketing of the art is part of the art itself.

When the diamond-encrusted skull was exhibited in London, the setup for viewing it was an artwork in itself. It was exhibited in a small gallery that had several security guards looking very ominous. The room the skull was in was almost completely dark, and there was a long line waiting to get in. Once you were in the gallery, you had a very short time to see the skull because you were moved through rather quickly. The problem was that your eyes didn't have enough time to adjust to the darkness in the room, so just as you were starting to see the skull on the way out, the angle of the light caused a spectrum of colors to come out of it, and then you were outside.

It was an incredible scene. You could barely see it, and once you did, it was all colors and reflection, and you couldn't make out too much. The result was like a vision or a dream of some kind. The press loved this, and so did the people lining the block to see it.

If nothing else, Hirst is an example of how far you can go in being creative and caring for every aspect of your work, including devising its exhibition and how it is seen and perceived and for how much time. He has opened the door for other artists to be creative in similar ways. It is notable that his work is fetching such high prices that most museums cannot afford it. This may seem beyond you, but his creative approach can be interpreted and used by any artist.

In 2017, Hirst organized a solo exhibition in Venice, Italy, *Treasures from the Wreck of the Unbelievable,* for which he made up a whole myth to present what looked like ancient treasures from a sunken Greek ship. Pieces ranged from Ancient Egyptian-like items to Disney character reproductions, encrusted with faux shells and coral. The *Treasures* show consisted of about 190 works, including gold, silver, bronze, and marble sculptures. He did the show in collaboration with a major collector. It was essentially a giant DIY pop-up show.

Treasures was hailed as both genius and the biggest art flop of all time—yet Hirst sold millions of dollars of art from *Treasures from the Wreck of the Unbelievable.* The reason it was considered a flop was because critics almost universally hated it, so the press called it a failure. Yet it remained a financial win for the artist and a show that would be part of his legacy.

In 2023 I saw his ads on Instagram for a new series of prints he sold aggressively. To know more of exactly what he is doing, follow him on Instagram and you will start seeing his ads. With online advertising like his, the campaign is completely transparent and all online of course. Just watch it to see how he is selling prints with his own language and tactics.

The lesson from Hirst is not that you must be as excessive or as over the top as he is and was, but that you can consider changing the rules of how things are presented, and ultimately, how the art is collected and talked about.

Thierry Guetta (Mr. Brainwash)

This is the story of an artist who has done something extraordinary in just four years. This notion, a wildly successful DIY pop-up, can still happen today. There are empty storefronts and factory spaces all over the world where a pop-up could occur.

Thierry Guetta began making art as a total unknown and was not represented by a gallery. Two years later, his work had already been sold at auction for over $100,000. Like Hirst, the art world also loves to hate him, and he gets dismissed by critics and the press on a regular basis. Guetta began his career as a filmmaker, but that is a stretch because he never actually made a finished film. However, he was making a documentary movie on artists who work in the streets, using stencils, spray paint, and sometimes sculptural elements to place their art illegally all over buildings, street signs, sidewalks, and more in multiple cities. Under the moniker Mr. Brainwash, he ended up profiling some important figures, such as Shepard Fairey and Banksy, in his unfinished film.

How it was done, in a do-it-yourself style: Guetta's story begins with him putting up posters of his artwork, in a graffiti style, all over Los Angeles. That was the beginning of the marketing, you could say, for his exhibit. Then he rented an abandoned building, the former CBS Studios in Los Angeles, and staged his own show there. Like Andy Warhol, he made prints as well as paintings and created portraits of numerous famous pop figures. He also created sculptures and installations. He hired other artists

to make most of it for him. He oversaw the entire process, but to make enough work to fill the gigantic building he was in, he needed people to manufacture and create new designs for paintings.

Guetta had no gallery dealer or art establishment representative, just employees. It was, as the press called it, a DIY show, a do-it-yourself exhibit. He must have spent a great sum making all this happen and has said that he asked people to purchase works in advance to finance much of it. He also hired a curator who had produced a Banksy show a few years earlier.

As a promotion, he said he was going to give away two hundred prints to the first two hundred people that came to the opening. That night, an estimated seven thousand people came to his opening. He sold almost a million dollars' worth of art! And in one bold stroke, the art world knew his name.

To this day, some parts of the art world continue to look down on Guetta or dislike him because he did not travel through the usual channels. He did it in his own way, on his own terms. And in my view, that is just fine because he is prospering off his work and doing what he wants. Like Damien Hirst, he is challenging the rules of the so-called art world.

Since that first show, a similar one in New York in an abandoned warehouse was also mobbed, and he gave away hundreds of posters and sold more work. As of 2024, his career continues to grow and he has over one million followers on Instagram.

Guetta's approach offers a way of looking at the world that could give you freedom to do what you wish on your own terms. And that is the idea of this book, to allow you to grow in whatever direction you wish, to interpret the advice here through your own lens, so it becomes your unique path that only you can build and walk on. This is a wonderful example of how an artist can not only work outside of the gallery system, but can create their own mystique, marketing, and sales on their own. Is Guetta's art good, and is he talented? In this case, as with the others, that is not a question for me to decide. Because, talented or not, he is making it in the art world, and I am interested in exactly how and why. Selling work at major auctions is the ultimate recognition in the art market.

When we examine an artist like this, for the purposes of this book, we are not determining if this is good or bad art; we are looking at his techniques for earning a living and becoming well-known in the world of art. Part of his initial success was due to his having mounted a show that was so large (over 125,000 square feet) and also to his status as an unknown artist. When you do something on a scale that is record-breaking, the press pays attention. It is a technique used by many promoters (to claim, true or not, that this is the biggest, the largest, the longest, etc. in a press release) and was one of the elements brought into play for this show. He also asked for the help of other people who had organized events in the past. Besides being a driven, obsessive artist, he was also getting all the help he needed. Banksy's film, *Exit Through the Gift Shop*, which tells Guetta's story using his footage, is a must-see for readers of this book. You will see more details of his story and probably find it quite inspiring. As with Banksy and Damien Hirst, he took the idea of an independent warehouse show to a new level. He was bold and brave enough to believe in what he was doing and took it one step further than most by making it on a scale that most never imagine. There are many lessons to take from this artist, but I think the most important one is that this is a way of working, a way of making it, that is new to the art world. It is rare to see an unknown artist rise this high and this fast, especially in this manner, separated from the art institutions that are normally the stepping stones to success.

2.

MORE INFORMATION ON HOW TO BUILD A COMMUNITY OF ARTISTS

Building a community of visual artists can be enriching and supportive for all involved. Here's a guide on how to create and nurture such a community, with a list of ways to start.

Building a community of artists

Identify Your Purpose: Define the purpose and goals of your artist community. Is it for networking, collaboration, skill sharing, or emotional support?

Choose Communication Channels: Set up online platforms like social media groups, forums, or dedicated websites where artists can interact and share their work. Consider organizing in-person meetups at local cafés or bars, workshops, or art-related events.

Engage Actively: Initiate discussions, share your work, and participate in conversations to create a welcoming atmosphere. Encourage members to share their art, experiences, and challenges.

Collaboration Opportunities: Create spaces for artists to find collaborators for projects, exhibitions, or joint ventures. Facilitate skill-sharing workshops or knowledge-exchange sessions.

Provide Resources: Share information about art supplies, techniques, workshops, and opportunities within the art world.

Positive Critique: Foster an environment of constructive feedback where artists can give and receive critiques to help each other grow.

Celebrate Achievements: Acknowledge and celebrate members' successes, whether it's exhibitions, awards, or personal milestones.

Encourage Diversity: Ensure your community is inclusive and welcomes artists of all backgrounds, styles, and skill levels.

Organize Exhibitions and Events: Plan community exhibitions, art shows, or pop-up galleries where members can showcase their work.

Nurture Relationships: Invest time in getting to know other artists and their work. Build genuine connections and friendships.

Another way to use this book is to form a group around reading it and taking actions together. Members of the group, even just three or four people, can read this book and then do the action together online using Zoom or a similar platform.

A group of artists can support one another and become an essential part of your strategy for more visibility and sales.

Reach out to find new people through local sources, like physical bulletin boards and online meet-up forums for groups with shared interests.

3.

MORE INFORMATION ON GRANTS FOR ARTISTS

When we delve into the realm of arts grants, we're peering into the world of financial support gifted by foundations to individuals like yourself. Unlike some forms of support, these grants often come with no strings attached. In this discussion, I will address the intricacies of applying for grants and share invaluable insights to enhance your chance of success.

Finding more grants

To uncover these opportunities, your local library is a treasure trove. Equipped with specialized databases like Candid, it's a sanctuary for grant-seekers. Be sure you're pursuing "Grants to Individuals," and a librarian can navigate you through this maze, relieving you of unnecessary expenses.

In a world where artistic grants remain a beacon of support, mastery of the application process can prove transformative. Guided by clarity, concise storytelling, and an unswerving focus on your art, you're poised to traverse this path with confidence, regardless of the outcome.

Let's look at one particular grant application to get specific.

The Guggenheim Fellowship

A shining example that I'm intimately acquainted with is the esteemed Guggenheim Fellowship, awarded to 175 individuals annually from a pool of nearly 3,000. The grant itself ranges from $50,000 to $65,000. Positioned as a "merit" grant, it is bestowed based on your artistic journey, recognizing your art and its worthiness of this prestigious fellowship.

I'm very experienced with this particular grant, which I write for artists once a year. I have seen six winning applications, so I know what a winning application looks like!

The act of applying can be disheartening if you aren't selected, fostering feelings of unworthiness or frustration in a seemingly biased system. Moreover, competition is fierce, with a mere 175 spots available from the vast applicant pool, yielding approximately a 5 percent likelihood of success.

However, through my extensive involvement in this grant, I've witnessed six artists triumph against these odds. What set them apart? The key lies in "clarity." Their applications not only showcased beautiful work, but they were composed with a clear, reader-friendly style that resonated with the jury.

This fellowship, like others, can be conquered. Let's delve into its components and structure, unraveling the secrets to constructing a victorious application.

The Guggenheim Fellowship application centers around two core sections, alongside supplemental materials. The foremost components are the Career Narrative and the Statement of Plans. Even seasoned artists occasionally misconstrue these sections' nuances, making them perplexing for many. To illuminate this process, let's dissect each part.

The Career Narrative, a succinct yet powerful piece, spans approximately three and a half pages. Penned in the first person, it unfurls your artistic odyssey, starting with your college years or the juncture when your artistic journey commenced. Employing plain, straightforward language, recount your evolution as an artist, interweaving your creative exploits with exhibitions, experiments, milestones, and even life-altering experiences. Consider it an autobiographical tapestry, guiding the reader through the stages that have sculpted your current artistic identity.

Avoid the trap of employing a résumé or CV-style list of events, for it fails to encapsulate the essence of you as an artist. Instead, unveil your journey, infuse your narrative with warmth, and grant the reader a glimpse into your artistic soul. Clarity is the watchword, and the art of composing a winning Career Narrative hinges on crafting a coherent, engaging narrative that demonstrates your evolution.

My affinity for guiding artists in this pursuit stems from the inherent satisfaction of reflecting upon one's artistic voyage. This process elicits a profound sense of achievement, as you gaze back upon the tapestry of your creative life. Even if victory eludes you, the act of tracing your artistic lineage is a cathartic endeavor, reminding you of your unique journey.

The Statement of Plans proves less intricate. Spanning no more than two pages, or even a concise single page, it crystallizes your intentions for the upcoming three years. Here, clarity remains paramount. Artists often misconstrue its purpose, believing a groundbreaking project is requisite. In truth, it's an opportunity to articulate your near-future endeavors, potentially fueled by the grant. Whether it entails a continuation of your existing work or a subtle shift, the focus is on transparency and straight-forwardness and what you would do even without the grant.

Strive to abstain from submitting an artist statement in lieu of your Statement of Plans, a frequent pitfall. Succinctly unveil your creative path, unclouded by jargon or verbosity. This section is a portal into your forth-coming artistic strides, not a platform for grandiose ideas. Simplicity reigns supreme.

There is also a document called the List of Works for the fellowship, which is confusing because most artists think this is about the images they are submitting; it is not, because images are asked in the second stage of this particular grant.

The List of Works is simply a CV. It is a list of your professional accomplish-ments, just like a résumé. At the top, list the most current exhibits and then the rest in reverse chronological order as it descends downward. Simple.

The last document is a list of references. A reference is someone who will send a letter to the Guggenheim Foundation if one is requested. I am often asked about who this reference should be. You are asked for three to four references in total. This grant specifies that the references cannot be people that have a stake in the sale of your work (like a gallery owner or dealer) but instead should be people who know you, like a teacher, mentor, or fellow artist, and ideally, someone who can write well.

The Guggenheim Fellowship application is emblematic of numerous grants, characterized by their reliance on "merit" or "project" criteria. While the former hinges on artistic excellence, the latter seeks a concrete, impactful endeavor. The Awesome Foundation is a prime example of a one form of "project" grant. Their succinct application invites innovative ideas with tangible results.

On artists statements for grants and awards

Here is a way of approaching the statement for a grant application.

These two artists won a New York Foundation of the Arts grant, and I have never forgotten their statement. I came upon this when I was reading about the grant recipients. They used their statement to say a bit about what they had done for the grant. But first, let me explain how a jury for a grant usually works. As they look through hundreds, perhaps more, of applications, this is how it is presented. Usually in a fairly dark room, or from a computer screen, just before they see your images, they read your statement. So that means your statement should stand on its own, so that after it is read, the jury is thinking, "I can't wait to see this!" That is the feeling you want to create, not confusion or anything that lacks clarity.

Let's look at the statement by Suzzy and Maggie Roche, two singers who were trying to get a grant for a sound-experiment project. This was their artist statement:

> Our new compositions were inspired by two tape recorded conversations. We studied the rhythms and tones of the two women and translated their vocal patterns and personal expression into a musical piece. We abandoned any preconceived notion of structure in order to follow the natural curve of their stories. After twenty years of writing songs, we have become increasingly interested in the way people speak, and intrigued by the idea that human voices are always singing.

Isn't that beautiful for some reason? Pleasant to read? If I were in the jury, I would be excited to hear what they were doing, and I would want to give

them a grant if it were even slightly interesting; why? Because even though I have no idea what their work sounds like, their approach is very poetic, and the last line is particularly beautiful.

Their idea that human voices are always singing is absolutely blissful, in fact. I want to believe that very much. It is affirming of life and art, and no matter what they do, I would want them to be able to continue their experiments. Wouldn't you?

Also, note the length of their statement; it is quite short and to the point. This type of artist's statement is less a summing-up of all their art and more specific to one project, articulating their approach. This is a method to keep in mind because instead of writing something long and partially biographical, it gets right to the heart of the matter without over-explaining or becoming dull.

4.

MORE INFORMATION ON INCOME STREAMS FOR ARTISTS

Income streams for artists can come from a variety of sources, enabling them to sustain their creative careers and support their livelihoods. Here are some primary sources of income for visual artists.

Art Sales: The most traditional and direct income source for artists is through the sale of their artwork. This can occur through galleries, art fairs, online platforms, or even directly from your studio. With galleries, artists receive a percentage of the sale price, usually 50 percent, with the rest going to the gallery itself.

Commissions: Artists can generate income by accepting commissions from individuals, corporations, or public institutions. These commissions might involve creating customized artworks, such as portraits, murals, or sculptures, to meet the specific preferences of the client.

Licensing and Reproduction: Artists can license their artwork to be reproduced on various products, such as prints, posters, merchandise, and even book covers. This allows them to earn royalties from each sale without directly selling the original piece.

Grants: Artists can apply for grants, fellowships, or residencies that provide financial support to pursue their artistic endeavors. (See appendix 3.)

Teaching and Workshops: Many artists share their expertise by teaching art classes, workshops, or online tutorials. This not only generates income but also allows artists to engage with aspiring artists and contribute to the artistic community.

Online Marketplaces: Artists can sell their artwork directly to a global audience through online platforms, such as Etsy, Instagram, or their personal websites. This eliminates the need for intermediaries and provides greater control over pricing and sales.

Fellowships: Various organizations, foundations, and government agencies offer grants and fellowships to support artists' projects and creative pursuits. These fellowships can provide financial stability and the opportunity to focus on artistic exploration.

Collaborations and Partnerships: Collaborating with brands, designers, or other artists can lead to income opportunities, such as joint projects, limited-edition releases, or cross-promotional ventures.

Diversifying income streams is crucial for artists, as it not only provides stability but also allows you to explore different avenues of creativity and engage with diverse audiences. Successful artists often combine several of these income sources to create a sustainable career.

Art consultants

The business of art consulting has a few meanings, but for the purpose of this appendix, it is the business of selling art to an intermediary who sells it to a corporation, hotel, hospital, other public or private institutions, or residences.

No matter where you are in your career, this is at the very least another income stream you can add. It is by far the fastest way for artists to get money in their pockets, but it is not without effort.

Like any new business venture, you have to learn the ropes and see what works for you. Very often, art consultants sell work on paper and other mediums to different clients, but unlike traditional galleries, they can handle many more artists because they must sell work in bulk. They often sell more conservative work, but not always.

Recently, many major buildings and institutions have come to want larger art for permanent display. There is a huge market in Dubai at the moment that many art consultants are trying to get a piece of. There are two ways you can approach the art consultant and interior design market. You can either begin calling all the consultants right away as an artist and asking them if they are interested in selling your work (the best approach). Or email them asking the same question. You will find out rather quickly just what work of yours they like and what they don't. Also, you will learn to present yourself in a businesslike manner. You can research them online or go to my website for more support and information:

The business model of art consultants

The business itself is very straightforward, but consultants will vary in the way they work. If you present yourself as a small business, very professionally and clearly, you will get their attention. They are not judging you or evaluating your work. They are just trying to make sales to their many clients. So if your work is organized and you are reliable and ship things quickly, then you will do well here, most likely.

In Praxis Center, I spoke at artist roundtables with several major art consultants, who explained how they worked with artists. There was Molly Casey of NINE dot ARTS and Wendy Posner of Posner Fine Art. Both are in the United States and work internationally. On both their websites they have information for artists to contact them.

Start an art consultant business?

If you start building relationships and are doing well with art consultants, I've seen artists who start their own consultancy. Once you learn how to work with consultants, there is another choice: You can be one yourself. Without any special knowledge other than experience, and the eye to choose art for different companies and establish a business practice, this is a wide-open field for new players. Both the consultants mentioned above have backgrounds in art.

Imagine a scenario like this. After reading this book, you decide to work with a consultant. You write to dozens and dozens of them, you tweak your presentation, and within a year, you are feeling comfortable and start to earn a decent extra income from sales through these consultants.

Now that you know the rules of the game, you could move up one step. Now you can work with artists and represent their work to the clients directly. You know how consultants work, and you can operate in the same manner. When approaching new clients, be businesslike and have your proposal ready and easy to understand. You do not have to take this path, as it's a big leap and a commitment, of course, but I wanted to be clear you have this option here. You can sell work through art consultants, but you can also be one yourself once you understand the business. These are options to consider as you look to new income streams.

5.

MORE INFORMATION ON OPPORTUNITIES WITH COUNCILS ON THE ARTS AND MINISTRIES OF CULTURE

Opportunities for visual artists, as well as interactions with councils on the arts and ministries of culture, can vary widely depending on your location and the specific policies of your country or region. However, I can provide you with a general overview of what these opportunities might entail and how they can support artists. I also have an ongoing blog on this, blog.praxiscenterforaesthetics.com/resources-for-artists/.

In the United States there are "councils on the arts" for every state, and in Europe there are "art councils" or a "ministry of culture" that serve similar purposes.

Here is a checklist of opportunities and support.

Grants and Funding: Many councils on the arts and ministries of culture offer grants, fellowships, and funding opportunities for visual artists. These grants can be used to support various aspects of your artistic practice, such as creating new works, participating in exhibitions, attending residencies, or pursuing further education. These funding opportunities can provide financial stability and enable artists to focus on their work. (See appendix 3.)

Exhibitions and Shows: Arts councils often organize or support exhibitions, galleries, and cultural events. Participating in these exhibitions can provide artists with exposure, networking opportunities, and the chance to showcase their work to a wider audience. Some ministries of culture may also facilitate international exhibitions, allowing artists to share their creations with a global audience.

Residencies and Retreats: Many arts councils and ministries collaborate with artist residencies and retreat programs. These programs offer artists dedicated time and space to focus on their work, often in inspiring

or remote locations. Residencies can provide a change of environment, access to new materials, and opportunities to connect with other artists. (see appendix 15)

Workshops and Training: Arts councils and ministries of culture may offer workshops, seminars, and training sessions to help artists develop their skills, learn about new techniques, and gain insights into various aspects of the art world, including marketing, business management, and copyright.

Public Art Projects: Some councils and ministries initiate public art projects that allow artists to create works of art for public spaces. These projects not only provide artists with commissioned opportunities but also contribute to the cultural enrichment of the community.

Collaborative Projects: Arts councils often support collaborative projects that involve artists from various disciplines working together. These projects can lead to unique and innovative creations and allow artists to explore new artistic horizons.

Networking and Professional Development: Many arts councils and ministries organize networking events, conferences, and symposiums that bring artists, curators, collectors, and other art professionals together. These events offer opportunities for artists to expand their professional networks and learn from others in the field.

Advocacy and Support: Arts councils and ministries of culture can also advocate for the rights and needs of artists within the larger cultural and political landscape. They may work to promote the value of the arts, support copyright protection, and create policies that benefit artists' well-being.

To take advantage of these opportunities, it's essential to stay informed about the activities and programs offered by your local arts council and ministry of culture. You can often find information about grants, exhibitions, and other opportunities on their websites or through art-related organizations in your area. Additionally, networking within the arts community and engaging in professional development activities can help you stay connected and make the most of the opportunities available to you.

6.

INFORMATION ON PAY-TO-PLAY
SITUATIONS AND EXHIBITS

No matter where you are in your art career, the idea of international recognition might be important to you. Some artists tend to exhibit only in their own country, or very locally, and that is fine, of course, but the art world is an international dialogue—an international showcase. This is evidenced by biennials that now are held in almost every country on the planet, as well as the numerous art fairs like Art Basel that we see traveling the globe. To be in an art biennial or a good international art fair like Art Basel are two ways to get major international recognition.

However, I want to strongly caution against ever—and I mean ever—paying for these opportunities. Do not pay to be in a biennial or an art fair. Even if it is Venice or Florence, do not pay for these, please. Biennials are nonprofit ventures, nothing is sold there, and you should not pay a fee to exhibit. It is the responsibility of the biennial to invite you and pay for your expenses.

I was invited to a biennial in Ljubljana, Slovenia, and they paid for my air tickets and room, and gave me a daily per diem, which was a small amount of spending money for meals. I came back from there without a profit at all, but I did not spend money to be part of that biennial.

The same should be true with an art fair. Even since the Art Basel fair became popular, satellite fairs keep popping up all around it, like Scope, Pulse, etc. There have also been people charging artists to show in a lobby of a hotel or a hastily constructed fair near the main Art Basel fair. Please do not pay to be in those, because you will not sell art in a fair where you are being charged for a booth or wall space—or at least it is extremely unlikely.

Some fairs may be worthwhile to pay to be in, but choose carefully because you will have to be fairly aggressive to sell work. There are

worthwhile cases in which artists pay for a booth and sell directly to the public—but it is a significant investment, and you risk not selling at all.

If you have a gallery, they should invite you to have work in the fairs in which they participate—the gallery then pays all the expenses of shipping, because they are getting 50 percent of your sales.

To get international recognition without paying for it, here is the essential pattern:

1. Apply to nonprofit residencies, and you will get into some. Often the residency itself will pay for travel and living expenses and you will meet curators and artists there while you work on your art in your own studio. This is an extremely important step for artists anywhere in the world. It is literally one of the most vibrant places of gathering for the international art community. You will see the language and the tone of the international conversation, and you will also meet people who can connect you to more residencies and even biennials. You can find opportunities using a website like rivet.es.

2. Visit international biennials online and in person, when possible, to see what art they are showing and how they talk about it. Keep track of what curators are putting on the shows, because if you relate to some of the work, these are curators you could pursue at a later time. If you can apply to the biennial in the future, then do so.

3. Apply for grants because when you receive an international grant, that fact alone travels in international circles and helps your recognition on a global scale. (See appendix 3.)

4. Apply to nonprofit shows and "artist-run" spaces, because these spaces are not selling work, they are presenting it for educational purposes. This is often where commercial gallerists can "discover" you. (But never pay—no pay-to-play schemes, ever.)

5. Work with a good commercial gallery, because then your work can be sold to collectors who have other great work, and it will boost your profile among collectors.
6. Take on commissions or other "commercial" work to support your career.

Those are the main elements of getting international recognition, that is, the attention of the global art community of collectors and curators. To clarify the reasons why noncommercial as well as commercial activity is very important, let me explain how they operate together.

If you are in a biennial, say, and have a gallery, then the biennial will generate attention for you (not sales), and the gallery will probably have an increase of sales because you are in a biennial. Without the biennial, the gallery alone might sell, but not as much and not to the global community.

The same applies to residencies. You will meet important curators at these residencies, even by Zoom, and that in turn can lead to a commercial gallery representing and selling your work, because independent curators that are part of a residency usually also work with galleries.

Finally, the last "commercial" idea is to use your artistic abilities in service of another income stream. That could mean painting portraits, for example, or doing interior murals. I know an artist who supports an art career that is often politically charged in approach with commissioned portraits. Her portraits generate an income stream so that she can keep pursuing her main studio work, which often gets exhibited but does not sell as well, or at least not consistently.

If you are a photographer, you have many options for commercial work outside your practice, and if you are a sculptor or filmmaker, again, you have the possibility of doing small, commissioned projects for people. Don't think for a moment this can hurt your other "studio practice" because, just like a teaching job, it will instead support it.

7.

INFORMATION ON SOCIAL MEDIA TACTICS

The love-hate relationship with social media comes from the huge glut of what can be perceived as viral garbage. There are things we want to read and see on social media platforms like Instagram, but there are many things we do not want to see that pollute our stream of information and can alter our mood for the worse. Think of political ads, no matter what party or country they are coming from; they are propaganda designed to sway you, using the most vulgar techniques. You have seen inflammatory headlines on which you know you shouldn't click, but you do it anyway because you can't help it. That is called "clickbait," of course, and you and I are the fish that click on it. They have titles like, "She's a liar, this video is proof!" or "It's us or him, impeach now!" or even nonpolitical ones, like "Photos that were taken seconds before tragedy struck," or "Ten ways to live a longer life."

These are all examples of viral garbage and clickbait, and as abhorrent as this may be, you are competing with them in the vast world of images and text. We must begin by thinking about viral garbage, because that trash is the context we are in when we send out our message to the world, be it a product, service, or work of art.

Identify your message

The first step in a campaign is to decide on your essential message that will be shared in many different ways. This may seem obvious, but what most creative people think of as their essential message is in fact often too general and not specific and focused.

Here are two examples.

Case 1: Inventor. If you are inventing a new case to cover a mobile phone, it would be easy to think your market is all mobile phone users that have a

phone that fits your design. That might be true, but there are many mobile phone users, and many of them have different tastes. While you think your target market is all phone users, only a fraction of those within that market are your actual buyers. Let's say that you have a design that is made from leather, and users can have it personalized with a monogram if they wish. This type of case can now have a more specific audience—the luxury market, for one, because it is more expensive than the average case. Because it can be monogrammed, it is also targeted to a certain class of people, like business executives who might want a monogram. Another unique factor is that the customers who might buy this phone case cannot be vegan because it is leather. Without going too much further, we already have a focus within a larger market that looks like this:

Mobile phone users > Specific model of phone > Luxury market > Business executives > Not vegan.

That is now a niche within a niche, one that will be much better in helping you look for customers. So, if you are about to launch a Kickstarter project based on that user profile, you now know whom to target in any ads during the campaign, which will save you money and increase sales.

Case 2: The Artist. You might think that the market for your artwork is very wide—it is anyone who can afford your work and likes it. That is a very broad market indeed but not an advantage, because you want to focus on the specific group or groups that will be interested particularly in your art. Let's say your art consists of figurative oil paintings on canvas, and that it is often political, satirizing current events. The images tend to be of political figures that are painted to look like crosses between cartoons and animals of various kinds. Sometimes words are added to the paintings. The work tends to satirize conservative causes, like immigration laws and tax benefits for the wealthy.

Without going further, let's reexamine what that means for the market that can be dialed into. It could look like this: Liberal or Democratic voters > Involved in an art organization > Reads *New York Times* or *Washington Post* > Lives in a major city. Now two of those categories you might think eliminate too many people (by limiting them what they read and where

they live. But narrowing the market using those two categories will allow you to spend less money reaching a targeted market, which you can then widen in the future.

It is always trial and error—by spending small amounts on advertising to a smaller demographic on a site like Instagram and watching for engagement, via comments and sales—through which you will identify a niche market that responds well, buys, and then can expand.

Leaders in online advertising: Google, Meta (Facebook and Instagram), Amazon

The methods used in the political campaigns I mentioned were the ones that many viral video makers use, as do advertisers everywhere—divide and conquer. They generate controversy so that you must take a side: "He's incompetent," or, "She's a liar." Then you have two audiences on opposite sides, and you send different messages to each side to persuade them to adopt a point of view about a candidate. You, however, are an artist, so your message and tactics are a bit different, of course.

The next step artists and entrepreneurs have to consider after defining their audience is how to divide that audience up into those who really want what you have versus those who are not interested at all. On Facebook, this process is called "targeting" your audience or "defining" that audience. On Google, it is a similar process. On Amazon, if you are selling products or art, your product will appear near the top of the list when products similar to yours are being searched.

Video content

In terms of promotion on Instagram and Google, which, unlike Amazon, are arenas where something can go viral, videos have the greatest advantage. By Google, I mean largely YouTube, the video site that is owned and distributed by Google. You have already seen their cute animal videos, or videos of something horrific, or uplifting videos from self-help gurus. If you want to make a powerful initial impression, you must think about competing with viral videos by trying to make one of your own. This is a most ambitious yet slippery goal, because there is no recipe for doing so—or is there?

Making a viral video

Some people make viral videos the cheap way—make a compilation of other videos, editing for just the interesting moments, and creating a "best of" viral video. A "best of" compilation video might be the closest thing to a "guaranteed" viral video. Most viral videos just happen to strike a nerve or make people laugh, and so they are popular. I am talking about them first because advertisers spend little or no money making these videos, and making one yourself will help you develop your audience and build an online presence. Just be aware that the problem with including other viral videos on your site is that it is likely not the audience you want, as you are looking for the art-buying audience.

The rest of this section includes more practical techniques that can get you more visibility online, with and without spending money.

One basic formula for online recognition and visibility:

1. Make a video → Post it on YouTube → Post to Instagram → Post to X.
2. Promote video in an ad on Instagram. Spend a small amount over seven days.
3. Retarget the people who watched more than 50 percent of the video with your next video or post.
4. Repeat daily or weekly.

Live videos: interacting with your audience

I suggest you make a live (not prerecorded) video at least weekly, during the daytime, but don't think too much about what day or time is best. Just make one regularly at whatever time suits you best, on the same day of the week if possible. You will begin to draw an audience, and you can see how many people are watching as soon as you begin to record. As you progress through your talk, you can see if people are liking it and that will let you know that your audience is enjoying themselves. While presenting the video, be sure to say that you will answer any questions after it is over. I would suggest keeping the video to about twenty minutes, more or less. At the end, answer questions that will appear in the comments below

the video. Now you can speak to your audience directly and answer their questions.

Video production

At first, this may sound intimidating if you haven't done videos before or are camera shy, but with some practice you'll work out all the kinks. After doing two or three, you will see how to interact with comments in real time and feel more comfortable in front of the camera. The camera, of course, is likely one that is built into most laptops or smartphones, so it will be easy to use.

However, there are a few tips to using the computer camera effectively for Instagram or YouTube live videos.

1. Keep the camera at eye level. Many amateur videos are made with laptops, and since they are on a desk or table, we often see a face looking down into the camera. This has a negative effect on your audience, because it looks like you are literally talking down to them. It also has a very amateur feel to it because we never see videos like that in professional settings—look at how newscasters face the camera, for example. Conversely, if the camera on your computer is too high, it also creates an odd effect of looking up, which is awkward as well. As strange as it may feel, the best practice is to have the camera at eye level and look directly into the camera.

2. Your title and description are important, but don't fret over them too much. Just make the title something clear and descriptive, like "Let's Discuss Matisse." That same title could be adjusted to other artists you talk about. Or, of course, your own art and studio.

3. The description can be less succinct, but make it brief, such as "A Discussion of Matisse: His Life and Art" or "A walk through my studio and recent work."

Then make your video, and when it is done, share it to your other social media sites. The next question—once you get a few of these done and see people reacting and see your audience growing—is whether to keep doing them just like this or start paying for ads to promote them. I would suggest you keep doing them without spending a dime and see how your reputation grows and how your audience responds. Then you can begin the next steps, if you wish, to begin paying for promotion.

For more information, see my book *Sell Online Like a Creative Genius*.

8.

MORE INFORMATION ON PATRONS AND SPONSORS

Isn't this the Holy Grail for artist funding? To have a private patron is the dream of many artists. Or at least they believe it is. It has the ring of what we imagine a trust fund would be like, or the romantic stories we have heard about artists living off the regular patronage of one wealthy donor. The truth is that the relationship of artist to wealthy donor is still alive and well, and it is something that I use to support myself. I will outline how you can create that kind of relationship. Like any other methods, it will take work and dedication, but it can also be fun and very rewarding.

Who can help?

First, there is the question of who could possibly help you. Depending on where you live in the world, begin to make a list of people who could be potential patrons. Generally, these are people with an interest in the arts and deep pockets. One of the places to meet them would be at your local museum or art institution. Go to the openings at museums when possible. Go to opening receptions at any arts center as well as art-related events. Go to Zoom or other virtual events!

Remember who you are looking for: people who don't look like the artist's friends, people who look like they have money. The way to organize yourself even better is to keep a list with pictures of everyone who might be a potential donor. The way to get that list is to begin thinking about who it is in your area who is interested in the arts and has money.

One method that I use and mentioned earlier is to go to the museum or art centers and find their website and look at the list of donors. There is also a board of directors listed or a group of donors that are the top level. These are the people you want to meet. All the donors to museums are people who could potentially be a patron and help support your work.

When you have a list of the people in your area who are donors to the art centers and museums, search their names on the web and find their picture. Most likely you will be able to find a picture of them on the web easily, but if not, just make a list with the names and whatever other information you have about them, like what museum or institution they are associated with and what social, artistic, or other causes they donate money to or are active in.

Then go out and talk to them at parties and at openings. OK, for most people, that is the hard part, talking to people you do not know at openings. Well, I know it is, and I will give you some steps to take, but you have to be bold and brave. It isn't easy for anyone, but this is how the relationship with a patron gets started.

Introductions on Zoom or at other virtual public events

Zoom and other virtual meeting software has made it possible to meet these same people even more easily in some cases. Adapting these techniques to the chat feature in Zoom and other videoconferencing software usually allows you to privately message other people in the meeting so that you can introduce yourself directly via a public or private chat or you can comment on what they are also interested in about the lecture or presentation you are both attending. Then after the virtual event is over, you can write an email to the person you heard ask an interesting question, perhaps, and introduce yourself. Thus, a conversation is started. In person, there are more rules of etiquette.

Introducing yourself in person

So let's take in-person meetings one step at a time. You have your list of people you want to meet who are potential supporters (museum board members, trustees, etc., from public listings) and you have their pictures, so you recognize them when you see them. Now you are at an opening reception, alone. Don't bring a friend, or you are sure not to meet the person you are seeking or even someone new, because you will be talking to your friend the whole time. Look around at the whole scene. See if you recognize anyone from your research. You may or may not see someone,

but look. If you don't see someone you know from your research, then be a detective and notice the small things. You may be able tell who is the wealthiest by the clothes they are wearing, their shoes, their watches, and their other accessories.

Now is the time to be brave; you really have nothing to lose here.

If you recognize someone or they just seem like they could be a good patron from their dress and attitude, go up to them, be confident, and hold your head high. Extend your hand for a firm handshake, and say, "Hello, my name is X, I'd like to introduce myself."

All the while, look at them right in the eye and be confident. If you act too nervous or skittish, you will make the person you are trying to meet feel the same way.

So do your best, and after introducing yourself, if they do not introduce themselves right away, ask them, "May I ask your name?" They will tell you, and then you can begin a brief conversation. Ask them what their favorite work in the show is and listen carefully to what they say. Respond to their words thoughtfully. If they say they do not like a particular work, ask why. Then in the conversation that ensues, offer your own thoughts. Don't make jokes, curse, or say anything negative.

Be upbeat and enjoy yourself. They will most likely ask what you do, and that is your opening to say that you are an artist. If they do not ask, then you can say, "I am an artist." And then add your own comment about the show and why you came there. Don't talk too long because you want to end the conversation gracefully. Take out a business card and hand it to the person you are talking to, with the printed side facing them so they can read it, and say, "I'd like to give you my card."

If you don't have a card, by the way, print some now! They still work, and it's easier than asking to scan their Instagram account or similar.

On your card, you just need your name and email address (or other preferred contact info) and either the word "artist" or something about your medium. I prefer just having the one word "artist" on mine. Then ask if you can have their business card. They will usually hand it right over to you, but even if they do not, tell them it was nice talking to them and to have a nice evening. Then shake their hand firmly, or simply smile, make

good eye contact, and move on to another person the same way. If you didn't get their card, remember their name, and write it down. At first you will feel awkward doing this, but after a little practice, you will get better and better, and before long, you will be collecting many cards from people who could be potential patrons of your art.

Using your contacts and following up

The next step is to go home and keep the cards you collected in one place. As soon as you meet someone and get their card, send them a message within twenty-four hours. Even if you don't get their card, remember to look up their names and find a way to make contact. You might not find their personal email address, but you can probably find a company address for them. Write them a polite email saying that you enjoyed meeting them and that you would like to keep in touch and give them a link to see some of your images. Then keep going to openings; you will see them again, address them by their first name, and ask them how they are and talk again about what you are seeing. This is the way I do it, and it is one of the basic ways to make new friends in a setting like this.

After meeting them twice, you can begin to ask them to lunch, tea, or a Zoom studio visit and get to know them better and tell them more about who you are. The idea, of course, is that you are making friends with people who can help you, and the next step is to ask them to help.

If you are doing this all virtually through online meetings and lectures that museums and other institutions put on, beginning a dialogue via chat and then email, the next step can be writing a beautiful letter on a gorgeous piece of paper—it is eccentric and it will get noticed.

Writing a beautiful letter

Once, when I met a trustee of a museum I wanted to talk to further, I asked her at an opening if I could call her and ask her advice on a new project I was working on, and she said yes. I tried calling her several times and only got her assistant. Then I asked her assistant when the best time to catch her was, and she told me between 7:30 and 8:00 a.m.

Since then I have found that the time to get people who have assistants is in the thirty minutes just before the assistant arrives. I called her back at that time, said hello, and reminded her who I was and that I wanted to ask her a quick question about fundraising. I proceeded to ask her how I should go about asking people for money for my artwork. She was very forthcoming.

She told me that in her experience, several things were needed for her to give money to an artist for a project. She said that when artists send her beautiful letters, by mail, she responds. By beautiful letters, she meant that the letter was handwritten on beautiful paper, in a beautiful envelope. And the letter itself was long, chatty, and asking for a specific amount of money. She said that when people send her letters like that, she not only writes back, she saves the letter because it is so beautiful.

She mentioned something very important, about how much money you are requesting in the letter. Like most people who are involved in the arts and give a significant amount of money to the arts, she has a foundation of her own that administers how the money is given out. That means that you can search online and see what her foundation has given to in the past. She said it was important to her that people knew who she was and what she gave money to and how much she had given. The reason for that, she said, is so that people don't ask her for too much or too little money, but an amount that makes sense. She also said that she doesn't like it when people only write to her for money and don't send her letters in between giving her friendly updates. At the end of our talk, which was about twenty minutes, she said, "When you get the letter done, send me a copy."

Sending the letter

Then I did much of what she said. I went to the art supply store, and I bought a few pieces of beautiful paper and an envelope to match. Then with a nice pen, I wrote out a letter explaining that I was having a show and that I needed $2,000 to complete the budget. She mailed me a check for $500.

Then I sent her a thank-you note, also handwritten.

Six months later, I asked her for funding again, in the same manner, and this time she sent a check for $1,000.

Every time I asked for more, she gave me about 50 to 75 percent of what I was asking. The amounts kept increasing. Now I count her as one of my regular patrons, who give me significant sums every year. What I have learned from her is that you must build a relationship over time. Sometimes I hear artists say, "I know this person is a millionaire, and they could easily write a check to me for $10,000." That may be true, but that is not how millionaires function, especially those with foundations that have to give in a responsible way. The way philanthropic giving is done is in small amounts that keep increasing, and the reason for that is so the donor can watch how their funds are being used.

Imagine you are a donor; wouldn't you want to make sure that your money is spent wisely? If an artist asks you for $10,000, and they are person with very little money to begin with, how can you be sure it will be spent wisely? They might promise you the world, but the only way to know for sure is to give the artist a small amount of money first and see what happens with it and how the artist communicates with you. That is what you can expect from someone that has a foundation, so ask for a small amount to help you build a relationship.

Charm

Once I was talking to the avant-garde theater director Richard Foreman, and I was asking him about raising money for different projects. He started to tell me about the late Jonas Mekas, who was the director and founder of Anthology Film Archives (AFA). AFA is a nonprofit institution in New York that is dedicated to showing avant-garde films, founded by an artist with the help of many other people. Mr. Foreman told me that Jonas Mekas was great at talking to wealthy people at parties. He said they used to call him "Saint Jonas" because he was so sweet to everyone, and they loved him. Foreman said Mekas was able to ask many people for large sums of money to support other artists, and they gave it to him. I never learned many more details of this story, but it was clear that part of the way he raised millions to build his institution was to befriend people in a charming manner.

You can start writing a letter today. Think of what you need money for: to complete a painting series, or make a new sculpture, or for the development of some other project or dream you have in mind. Then write it down and get into it, get excited about what you are writing, and express that with enthusiasm so the person you are writing to feels it and comes along for the ride. Then when you send updates, continue the excitement of your accomplishments.

Negativity

A special note here is to remember not to be too negative or say something desperate, such as that you need the money because you are broke, even if that's the case. The reason for that is simple: people want to fund your dreams, not pick up the pieces. They want to attach themselves to someone who is flying, not get on a sinking ship. Put yourself in the position of donor again. If you are about to give a small or even a large donation, you want it to really make a difference, you want the artist to be happy and grateful, and make their art—and you want to hear about it in the future. A relationship is starting.

The last note about writing a beautiful letter is to come up with other ways for the letter to stand out. I often use sealing wax on the back of the envelope, and I use an old coin to emboss it. It looks beautiful and is one more way your letter is standing out from all the rest. Or consider scenting the letter lightly with perfume!

That is what I do, and it is quite simple and very human. We all want to feel that people appreciate us, and the more we hear it, the better. Can you tell someone too much? I don't think so. If you sent someone a letter every week saying how much you appreciate them in different ways, do you think they would find that annoying? I know I wouldn't.

The more we hear that someone appreciates us, the more we want to help that person to keep the gratitude coming. Just like giving presents. When someone has a wonderful reaction to a present we give them, we want to give them more. It is a natural reaction. We all want to be happier and more grateful, even if we don't acknowledge it. We want to be more alive and share in the enthusiasm of others; that is why being

enthusiastic and grateful to those who support you will take you very, very far.

Offering donors something special

One of the first ways I decided to get sponsors for my work shortly after I graduated from college was not by the example above but by asking them to pay for artwork in advance.

This is something you could do right now, and it is one of the easiest ways to get funds fast.

You can write a letter that begins with "Dear Collector," and send it out to everyone that has ever bought any art from you. Send it out to family members or even friends who you have given your art to, because they are all "collectors" of your art whether they realize it or not. If you can only come up with five or ten people, including family, that's OK; send it to them.

When I wrote my letter, I sent it to a few people who had bought my work in the past or were given it as a present. I was making abstract monoprints then, about twenty by thirty inches, on paper. All the prints were in fact originals, much like selling paintings on paper. In the letter, I began as I mentioned above and then quickly explained that I was working on making a series of prints. I also said that I was writing to them so that I could make a large edition of work at a special printmaking studio. I needed funding, and I had an offer I wanted to make them.

This was the offer in my letter: I explained that normally my monoprints sell for about $1,000. (I had never actually sold one yet for that amount, but I thought they were worth that!) Then I said that I wanted to make them a deal if they bought work in advance, which would help fund my time at the printmaking workshop in NYC to produce a new series of monoprints. I explained: If one print is $1,000, then five prints would be $5,000 if you bought them from me directly now.

Here is the deal to help me fund my dream—For $2,000 now, I will give you $5,000 worth of artwork (5 monoprints) and a handmade box worth $200. (I knew where I could get the portfolio boxes custom-made for me, at about that cost.) I closed the letter by saying I was grateful for their past support and to ask me any questions.

I sent the letter out to fifteen people, and five of them sent me checks for $2,000 each—that was a fast $10,000! I was offering them a financial deal that seemed to be a very good investment. The actual numbers I put at the end of the letter again, so the deal was clear to them, that is, for $2,000 now, you get over $5,000 in art and a custom box shipped to you. I was thrilled when I got the first $2,000 check.

This was the first time I had ever asked for money, and it worked. With that money, it was easy to make the custom boxes, which cost me $1,000 for five, and then I had another $9,000 to make art. That made a lot of art, indeed, and also paid bills, took me on a short vacation, and more.

Emergency funds

Another way to use this same technique for emergency funding is as follows. Let's say you have a flood in your studio and work got destroyed or damaged. Or maybe some other emergency happened, such as a health crisis, or perhaps your landlord raised the rent, and you have to move your studio.

You can write a letter similar to the one I described above and explain your situation. Be clear and honest, and you won't have to dramatize anything. Just state the facts of your situation. Then tell them that what you need is help until you get your studio back or your health back, whatever it is. Explain what you would like from them. I would suggest asking for a certain amount, say $500, and tell them that if they give you money now to help you through this crisis, then they can pick out a work from your studio that is worth double the price. So if they give you $500, then they can come to your studio and they will have a credit of $1,000 toward any painting. And if they give you $1,000 now, they will have a credit of $2,000 toward any painting in your studio.

This is a very good way to make a bridge for yourself in difficult times. It will allow you to not only move forward but also will begin to create and deepen the relationship you have with your collectors and even family members. Once they give you the money, then you can write to them and tell them how it has helped, what you are doing, and other updates. It may seem like a strange statement, but it is really a gift to be able to have the

opportunity to help someone financially. It is rare that someone asks in a polite and professional way for help. For the person who is being asked, if you know them, it is a chance for them to comfort you and assist in your creative process, and that in itself is a gift to them. I often give small amounts of money to different projects on Kickstarter, and I am always thrilled by it.

Giving money to others who need it has its own special reward for the donor, including a splash of dopamine, which is hard to appreciate unless you try it.

Corporate and business sponsors

Asking corporations for sponsorship is one avenue to consider when raising money for a project or a series of paintings, sculptures, or any other art-related work. To begin with, if you are asking a corporate sponsor for a donation of product or money, there has to be something in it for them. That typically means there is publicity of some kind. If you are asking a company to donate art materials like paint and canvas, then you must think about how they will get attention for it. You see, the incentive for a company to sponsor or support your activities in some way is to get back what they give you in the form of publicity and good will. Examples of that might be a class you are teaching where you tell all the students to use the materials of the company that sponsored you, or an exhibit where you expect people to come and see the materials in action. It could also be in a lecture you are giving about your work or something where the company that is sponsoring you is getting attention for their products.

Not accepting "No" for an answer

My first experience in successful corporate sponsorship was with Apple computers.

I wanted some of their product for free, about 40 iPhones to use as a video display in an exhibit. But I couldn't find a number or email address that had anything to do with sponsorship or questions like that from Apple. I only received recorded messages.

The next way I tried to get to Apple was by calling the local Apple store. I knew at least I would get someone on the phone there. I explained my situation again and said I just wanted someone to talk to, not a recording. They gave me the number of someone in their business department. I called him and explained what I wanted. He said he had never seen them give products, but it wouldn't hurt to try.

So I sent him a very short email that had the subject line "40 iPhones and an art show." I quickly explained that I was having this cool show and wanted Apple to consider giving me iPhones for it, that didn't need to be able to call, just play video. The letter was brief, to the point, and was filled with enthusiasm. One day later, I got a response that said, "Thank you, we would like to do this, tell us when the show is close." I was stunned. I also wasn't sure I even understood the brief response! But yes, they were giving me the iPhones!

It was such an incredible feeling to be given that much product, which turned out to be a lot of money as well—when I asked Apple if they wanted the phones back, they said no. I owned them now and after the show, I was free to sell them used, which paid for even more of the show! In general, what you can expect from corporations is that they will usually not answer quickly, or they will say no.

Again, there are no rules in asking corporations, so just start calling and asking. It is amazing what can happen. I also wrote to Bose audio equipment and asked for forty pairs of headphones to go along with the iPhones. I had to make many calls to follow up and get an answer, but finally they said yes.

Always keep in mind that in your letter, you must explain to them why you need them and, most importantly, why it will get seen by a lot of people. They are looking for exposure and more visibility of their product.

The department at both corporations that I reached was something called "buzz marketing" or "product placement" which is separate from their "marketing" department. Buzz marketing is where they help with some event or exhibition and the company potentially gets social "buzz" or press. Product placement is similar—when you see Mac laptops and phones in movies and on TV, they are probably giving the filmmaker

money or product, which is helpful for the visibility of their business, even if they are as well-known as Apple.

Wealthy friends

I was in a local restaurant with my wife talking to a young, charismatic waiter who had just gained admission to an elite high school that he described as looking like Hogwarts of Harry Potter. We asked him what he wanted to do, and he said, "I want to be a governor of the state or something like that, in politics." As he told us more, he also described his main hurdle. All his new friends at this school, he said, come from extremely rich families, and he lives with his single mother, who doesn't have much money. The key, he said, was to figure out how to get all that money to run for office. He hoped his friends would help him, but he made clear that without a lot of money, he could not even come close.

It was exciting to hear his enthusiasm and see his bright teenage eyes. It seemed like he was making a bold move that had a good chance of working. When we returned to the restaurant a year later, we asked him how school was going. With a smile, he said he had changed his plans. He told us that the other students had their own set of rules for how life works out. He said he found that their outlook was mean-spirited, and he wasn't interested. He dropped out. Now he wants to make videos or open a coffee shop, but for the time being, he continues to work in the restaurant.

How we communicate and view the wealthy determines how our relationship with them will turn out.

Small donations lead to larger ones

Winning friends is certainly a social grace, but for the moment, consider the historic 2008 presidential election.

Barack Obama began running for the Democratic nomination for president against Hillary Clinton, who already had all the big Democratic donors in her pocket. Like the waiter in the previous example, he needed to raise a lot of money, ideally even more than Hillary Clinton!

We know now that he did just that, and it was largely because he used the internet extremely well as a networking tool, perhaps the first presidential candidate to really do so.

He went beyond traditional friends and supporters to generate new revenue and used all the social platforms to make bridges. Instead of getting the large donors, Obama raised enough money by seeking the small donors. And, as we now know, he was successful.

What do donors want?

Everyone wants a friend that will give them a break, but it isn't always about an introduction or who you know; in fact, it is as simple or as complex as making a friend.

How does one go about making friends? Well, in the online community, there is a strategy that, again, is very similar to dating.

In the business world, when you want to get someone's attention, you think to yourself, "What do they want?" For example, if you are in the business of selling golf balls and want to reach the organizer of the Masters Tournament, you must figure out what they want. Perhaps you have researched this person and notice on their Instagram page or in the news that they have an interest in watching birds or some other hobby.

One of the ways to get to this person is to ask him or her a question about birding or tell them a bird story. Does that sound strange? Perhaps, but it is human nature; we are interested in our own ideas, hobbies, and dreams, and if someone else asks us about them or helps us with them, we feel a bond with and become very interested in that person.

Making real friends

The steps to begin building relationships are not that hard to follow, but first you have to decide what kind of friends you really want. If you are trying to build your career, to become a professional artist by doing your best to exhibit and earn a living from your work, then you need people who will support that effort. You want to meet collectors, gallery owners, curators, directors of nonprofits, and more.

The next step is to get out of the studio and do what is perhaps the most difficult part: begin talking!

To begin with, as I have said, you should start by finding out what museums and galleries are in your area and the dates of any art openings or even poetry readings or other events at the museum. You can do it all, or most of it, from the comfort of your home or studio through Zoom in many cases.

This is a great way to meet interesting people who can help you. The reason you are going to the museum events, virtual or not, besides it being fun, is that there are often collectors and museum supporters at openings. There are others who are simply interested in art.

It will pay to do a little research before you go to the museum. It will help if you go to the museum's website and find the list of museum supporters and board members. If they have pictures, look at them and read the little bios about each one. Consider printing out the pages of brief descriptions of some of the people you may meet at the museum opening or even virtual Zoom event. Have fun with this; it's like being a detective. Yes, it is calculated, and so will be the expressions of your desires, if you take things step by step in this fashion.

Openings and parties

There are now virtual openings and parties as well as physical ones. So the next step is, of course, to actually go to the openings or events one or two nights a week and do very little at first, just look around. (Or drop into Zoom virtual events and listen and watch.) Enjoy the art, the atmosphere, have a few nibbles, but not any wine, yet. (If you are doing it virtually, it's the same, refrain from drinking as it often inhibits bravery.)

If you have been researching some of the people from the museum, see if you spot anyone in the crowd or in the Zoom talk attendees. If you are there for the first time, don't push yourself, just watch. See how people talk to each other, watch hand gestures, and listen in on the topics of conversation. Look at what everyone is wearing. It will give you a feel of what people are talking about and how they present themselves. Can you tell anything about the people you are looking at? Try to figure out who looks like they work at the museum.

Talking in person versus post-event emails

After watching an opening like this for a while, you can go home the first time without talking to anyone and also even the second time if you are feeling uncomfortable. But at some point, when you are at an opening, find someone there to talk to. These are some of the games I play when I am in a new environment with the possibility of meeting interesting people.

If you see someone in particular, like a curator or museum director you recognize, you can introduce yourself in this way: Walk over to the person and, while looking in their eyes, say, "Hi, I would like to introduce myself, I am X, and I am really enjoying this show." That or something similar is all you have to say. For many people, this is very difficult at first, of course, but you have nothing to lose, so try it! You will find after doing this a few times, it is really quite easy.

After you introduce yourself and say that you like the show, you can either be silent and wait for them to respond or simply say thank you to them if you know they work with the museum. You can leave it at that or tell the person why you liked a particular work of art there and ask them what they think.

Directing the conversation to something in the room is a good technique, because then you are not focusing on either yourself or the person you are just meeting, but a topic of mutual interest. This is the way to get everywhere, because as you practice, you will find that you get better at talking and better at introducing yourself. I know this may all sound very basic on some level, but it comes down to that. When you go to parties, you probably have the tendency to meet other artists and stick with them. So, to meet other people there, it must be a conscious act, knowing your goal is to meet new people who could help you.

One artist told me that the way she addresses this difficult action—to start a conversation with a complete stranger—was to think of herself as a "stage mom" to herself. In other words, she said as with a child actor that wants the roles but does not want to do the audition, she imagines herself as the stage mom to that actor, saying, "It's OK, you can go on stage, I'm right here, you can do it, this is how you get the chance to get the role you want." You could use her method and be the stage mom to yourself when

you have to do uncomfortable things to advance your career, like make new rich friends.

The right questions to ask

When meeting people, ask yourself: how can they help you? How do you know if you are in front of someone who could really do something for you? The more questions you ask them, the better position you will be in. Sometimes I ask the fairly dry question, "What brought you here?"

And try to find out more about what interests them in the arts. Because I am always endlessly surprised when I ask people what it is they do; people tell the most amazing stories. And often the connection is much greater than what we might have presumed.

The idea is to just talk, ask questions, explore, and you will meet engaging people who will inspire you.

Ask what their favorite piece is in the show, or why they like or dislike something. It's OK to fail at this a few times, with the conversation ending awkwardly—just keep trying, and you will soon be talking to someone interesting. The next step is to keep in touch with them by getting their email address, ideally, and mailing address. One way to get an address is to say, "I would like to keep in touch."

It is easy to get almost anyone's email address, and you can always look it up afterward (just remember their full name). Virtually, through Zoom, it may be easier to ask for contact info and you can see their name as the user in chat forums.

When you have one or more email addresses of people you have met who seem like they could buy your art or fund a project, you need to write a letter. Your letter should be polite, brief, and end on a positive note. Be friendly and ask the person for a date to have tea, coffee, or another drink. That's right, the next step is to take the conversation away from the party or the museum or institution and into a café or restaurant, where you can ask them to be involved in a project, for advice on fundraising, or for a studio visit.

Now, let's take those one at a time. There are certainly many more things you can ask for and base a meeting on, but for now, let's go over what a "project" is and how to propose and discuss it.

Arranging a meeting

If you are meeting with someone to talk about a project of yours, by Zoom or in person, then say in your letter to them that you would like to ask their advice about your project in the third paragraph. The idea of a "project," so to speak, is really very new in the art world.

What is a "project" in terms of art and the art world? Though the definition will change with time, I am sure, at the moment, a project is a fairly vague term that describes an idea an artist has, which either incorporates the artist's art into an event of her making or is an idea that is purely creative and has very few, if any, boundaries. It could be a film, a musical, a painting exhibit.

An example of a visual project: "My project is to exhibit my paintings in a room meant for relaxation and meditation."

An example of a project with no boundaries: "My project is to make wishes and draw them for one hour a day, in silence, for a year, trying to get the moon to change its axis."

Those two examples are very different. The first we can understand very easily. If you are having a show of your paintings and you want to incorporate dancers, music, entertainers, or anything else into it, you are creating a project. It is simple really, just a statement explaining your artistic intentions in an exhibit that is beyond the artwork itself. An idea, in essence, that is about how your work is presented to the public with an awareness that the idea itself can be part of the art.

In the second, rather odd, example, about wishing for an hour a day, for a year, to change the moon's axis, there is more flexibility because anything is possible. It is, of course, also very abstract and conceptual (idea-based). But a project in this realm means it could be entirely a thought about something. Because of the times we are living in, art has come to the point where collectors and the rest of the art world are open to hearing something new.

They are open to hearing any idea from any artist because anyone can have a new idea or project or way of seeing the world that is of interest to someone else. And that is what we are talking about here. We are discussing what you will say to the person you have met at the museum or

museum Zoom talk. What is it that you will talk about over tea with them in a café?

What to discuss

Will you discuss your project? Now that we have some sense of what a project is, you can decide if you are the kind of artist who wants to talk about that. If you do, then decide first what your project is. Let's say it is the project where you want to exhibit your paintings and also have some type of entertainment with the opening or even part of the exhibit. The entertainment—jugglers, for example—help reflect what is happening in the artwork or have some connection to it. It could also be people meditating in the room, or a film, lecture, or reading.

If this is the project, then the reason you would like to meet Ms. X or Mr. X from the museum party is to discuss a project, an event that you could use advice on. One of the key words there is "advice." Keep in mind when you are sending emails and asking people for a meeting, what you want is their advice. Be clear about this in your email to them asking for a meeting. If you have to elaborate with them on the phone, just say it is an art event that you are planning and looking at different options to produce it, and you would like to share the idea with them and ask their advice.

Then have your meeting and discuss your project. To present your project at a meeting, do the following: Bring a sheet of paper—instead of using your phone—that has the project described on it in brief terms. The kind of text you might see on the wall of a museum, explaining what you are about to see, written for the general public. With that sheet of paper, bring no more than six printed images that represent your project. I strongly suggest you bring even fewer, like three images and your page of text.

What you will do is talk and show only a little bit. That is why it is very important not to show images on a computer unless really necessary. This meeting is about building a relationship, not a lecture on your work.

Bring an extra copy of the text. After sitting down, first talk a bit about what the project is. You are a painter (or a filmmaker, or another type of

artist) and you want to have an event and bring in different elements to build excitement and have a memorable time.

When you are ready, show your friend a few of the images you have printed out. Do not give them the text yet, just talk about the show and how you see the whole project coming together. After answering any questions, it is time for you to ask a question. In this instance, your question might be, "Do you have advice on any venues where I might create this event?"

Then wait for an answer. This is the kind of question that can get you a lot of help because the person you are talking to can evade giving his or her direct help by offering you names or resources. You might also ask, "Do you know who might be interested in getting involved with a project like this?"

Again, the idea here is to get pointed in different directions, to other people or institutions. Because after you are done with this meeting, you will ideally have a few references and leads in your hand to make other relationships. And now it is getting personal, because so-and-so just referred you to someone and you can use their name. That is one example of how to present a project to a new acquaintance that might be able to help you either through their primary network or business or by referring you to a friend or resource. This tactic will work for curators as well as collectors or those just interested in the arts.

9.

MORE INFORMATION ON NETWORKING

A website is not the only way to show your work online, of course; we have Facebook and Instagram (both owned by Meta), X, and other sites, which are free and make it easy to put up images.

Facebook is far from over and is still a useful networking tool, as is Instagram.

I think that a website, a simple one, is necessary, but social networking will help drive traffic to your website. There is much more to Facebook in that you can actually meet people who can help you and who are real. The same goes with Instagram, which is currently the dominant platform for artists. For example, most of the people I follow on Instagram are involved in the arts. I look at other pages, in particular art critics' X pages, and identify people who are interested in the arts: collectors, museum directors, artists, and more. It is amazing how you can connect directly with people. If you search on Threads, X, or Instagram for "art collectors," you will see amazing resources for meeting collectors. There are groups of collectors and all kinds of pages for them.

This is a valuable resource. I have written directly to collectors introducing myself and asking them to lunch or a Zoom meeting. I have met with museum directors this way as well, and I think it is one of the best networking tools for artists. Instagram and Facebook are great ways to not just exchange messages and become friends, but to actually meet people in the real world, which is more personal than just writing.

Building a community online

There are many ways to promote and share your work on Instagram, but I will go over a few basic steps.

1. Begin by following art-related accounts, such as collectors, curators, gallery, and museum staff. When you follow

someone, send a personal note, even if it is the same one to everyone. Something simple like, "I would like to be your friend because I like the work you are doing with [something related to them], and I would like to keep in touch. Sincerely, [you]."

2. As you build up friends, start commenting on their posts as much as possible (a few times a week would work). Spend part of each day, maybe thirty minutes or so, sending notes or making comments on other people's postings. Write thoughtful comments on posts by people you want to befriend. If you have received similar comments, you understand the value of this. If someone comments on a photo or comment of yours, you take an interest and often write back. The more sincere and interesting the comment is, the more response you will get.

3. Post images of your own new work. Try to avoid talking about your pets, children, domestic minutiae, and other nonessentials. You want this to be productive time, so use it that way.

4. Warning! Do not use the same password across accounts, like Gmail, because that makes you an easy target for hacking. That might mean someone breaks into your Instagram account and sends commercial messages to all your friends. Beware. I know that is basic, but a hacked site can ruin your day!

5. The last Instagram tip that I would suggest is to limit your time on it, for while it may be a helpful tool, in excess, it is a major time waster. As of this writing, in 2024, Instagram is still the biggest platform for artists, but there are many, many others, some of which are yet to emerge. So keep your eye out for new forms of social networking that are sure to arise, such as Threads.

Presentation and lecture tools

When you begin to present yourself and your work for different audiences, you need a basic plan to begin with. But first let's talk about the audience. Are you presenting your work for a grant or fellowship? Or presenting your work for a university audience? You might want to present your work and yourself to a potential funder. All of the above require a similar approach with slight differences in tone or delivery, but how do you create a basic presentation?

Traditionally, PowerPoint had been the digital tool of choice for presentations. At this point in time, I would suggest Prezi, which is a very sophisticated update of PowerPoint presentation. You can still deliver a certain amount of information in a narrative order if you like, but there is something more interesting and dynamic about Prezi. To begin with, you first assemble in a folder on your computer some things related to your presentation. Then, instead of the typical PowerPoint slideshow, you are using a nonlinear approach. Prezi has a way of letting you put all your information down on a desktop, your pictures and blocks of text, and then you simply draw lines between them in the order you want it to be presented. It is very visual and easy to use, so I suggest going to their website to see it for yourself. The advantage to this is that you can present it directly from your computer, or it can remain on the Prezi website so you can present with any computer that is online. If you feel uncomfortable with it, PowerPoint is the next best option, but I strongly urge you to explore Prezi, as it is much more exciting to look at.

10.

MORE INFORMATION ON SALES

Selling art on the street

Selling art on the streets of a city may not be for you, but consider it for a moment. In New York City, and in many other cities and towns, artists set up small tables on the street and sell their work. The savvier artists are selling matted photographs or prints of some kind, in the range of $25 or two for $40. But that sounds too inexpensive, right?

These are prints, and profit is made in multiple sales. The artists selling on the street are able to get a license to do so fairly easily because they are selling their own art, which is allowed in many major cities.

Of course, many artists set up with no license at all. It is a legal process to navigate but once you have a spot on the street and, ideally, a license to sell, you are ready to go, with very little overhead. This is a valid system of making a real business outside the traditional art market. The artists that are doing very well on the street are selling inexpensive matted prints, but also they are usually hiring others to do parts of the work for them, thus increasing how much they earn.

It is a fairly simple business plan. If matted prints of your work (which can mean common color copies or something just as inexpensive) cost you about $4 each to make, then you could give someone $2 for every print they sell. So if they are making $4 for selling two prints at $25, you are making $17 on each sale without being there. Not too bad, is it? You could also sell matted prints to boutiques or small stores at wholesale for $8 each. You make $4 with every sale.

I am outlining this simple business model because to many readers, this may seem like the least attractive way to sell art, but it is also an easy way to see how sales and profits are made. I have seen artists create street sales on many levels, and it is helpful to discuss because it is such an independent venture, and the model can be adjusted in all types of ways.

Selling art online

Selling online is now a powerful method and the dominant way that art is discovered and bought. There are many ways of doing this, and I will outline a few of them.

The pandemic created numerous new systems that continue to be used because of their conveniences and their ability to aid or replace older systems. Education is one of those systems impacted, because while we will still go into classrooms, we have an online component of all levels of education that will likely continue. The same is the case for visiting a doctor—"telehealth" is now a permanent part of how we interact with doctors.

Case studies for online sales

One example is Abbey Ryan, an artist who sells a painting a day on eBay and earns almost $100,000 a year from it. She has a blog, a website, and a way to remain in the studio all day and make a living at it. She was written about in business blogger Seth Godin's book *Linchpin* as an example of cutting out the intermediary and bringing work straight to market. Abbey Ryan does not need to leave her studio to make these sales happen.

Another example is Ashley Longshore, who sells her work through Instagram and through her website, where she makes it easy to purchase work through a typical, simple checkout cart system. Her paintings regularly sell for $20,000 and more. Her Instagram is what builds the buzz, and she also spends lots of time sending out press releases and looking for a way to get more attention. In recent years she had a show in a clothing store, but not just any clothing store; it was at the Diane von Furstenberg store in Manhattan.

After mounting the show in her store, famed designer Diane von Furstenberg herself not only appeared in a video of Longshore's, but so did the model Iman, who was gushing about Longshore's artwork. That drove more sales; you can see all of this yourself on Instagram or by doing a search. That is the kind of out-of-the-box attention Ashley secures, and it has taken her very far.

Selling art: a role playing exercise

Sometimes it is helpful to see what it feels like on the other side for just a moment, so here is one exercise I like to do to learn about behavior. Dress conservatively and go to a gallery. Make it the largest gallery you know of that you can easily get to—and preferably the most intimidating.

Once you are at the gallery, look around at the artwork and ask to speak to someone about it. Either a gallery employee or the owner will come out. They have no idea how much money you have, so with an air of confidence, ask the person approaching you to tell you more about the piece of art you are looking at. What you will hear and see is the selling of an artwork. And since you are perceived as a possible collector, telling them nothing about yourself other than your question about the art, they will do their best to sell you the work.

The advantage to this is twofold. On one hand, you get to be the person in power, the collector, and on the other, you can observe and learn as the gallery owner tries to sell you artwork.

The insight that you can gain here is in how they describe the art and what they convey to you as they try and sell the work. Pay careful attention to their words because this is how the gallery owner likes to talk about work. Then you can learn how to describe and talk about your own art in terms of its value to this particular gallery. Be sure to ask questions, such as, "Has the artist sold many of the works in this show?" or, "Why is the work valued at that price?" This can be fun and very educational. It could even start a new career for you as an art buyer for collectors! However, for our purposes, it is about building confidence and getting out into the world of galleries without having to feel as though you are ready for it. You are never obligated to buy something after a conversation, so be brave and try this. I think you will find yourself smiling afterward.

Again, this is just an exercise. You don't even have to give your name, just say "I prefer not to" if you want to leave your name and details out of the conversation—that may even intrigue them more.

You will find some people likeable right away and others less so, but it all has to do with how they talk about art. So try to imagine if this is a person you would want to work with by the way they are talking to you.

You can always follow up later. There is no need or pressure to introduce yourself as an artist in these types of role-play interactions, as you are just researching—and building confidence in yourself.

11.

MORE INFORMATION ON A "FUNNEL" SALES SYSTEM

The online funnel for sales

Selling art online can be a very calculated and specific process if you use advertising online to build a list of collectors, and then allow those collectors to purchase work from you by making it available to purchase.

This is at once one of the more straightforward methods and also a complex process. My book *Sell Online Like a Creative Genius* outlines the process by which artists as well as other businesses sell things online. As an artist, you can use the same tools and techniques that any advertiser online uses to find a niche audience and begin communicating with that audience.

Here are two types of "funnels" to generate sales online:

Funnel No. 1: The essence of my book about selling online is that a "funnel" is the process by which you acquire a collector and then sell work to them. It works like this:

1. You run an ad on Instagram, Facebook, or both.
2. The ad collects emails of interested collectors without selling them anything.
3. You send automated emails (pre-written) to those collectors so they can buy a work of yours or contact you about the art. That is the method that all advertisers online use, and most likely, you have already bought something that way.

You perhaps just clicked on an item (which shows interest) and then you kept getting ads or emails about that product. In that process, something specific and complex happened. What specifically happened was that you showed interest—maybe you looked at an item on eBay or Amazon or

another site, and then you see more ads for that same thing wherever you go online.

The same thing can happen with your art. The complex aspect of that process is called "retargeting" which means that as soon as you show interest, ads are then sent to you specifically to engage with that reflect that initial interest. You can either do all of this yourself, hire someone to help you, take a course, or let another platform partly do it for you.

For example, if you have a painting for sale on eBay or Etsy, and someone looks at it, they will begin to see ads for your painting wherever they go online. eBay and Etsy are partly doing a funnel for you—they are doing the "retargeting" part. However, you are not personally collecting the emails of those interested, so after eBay or Etsy stops retargeting, which is just for a few days, that interested person is gone.

If you want to make a funnel, it takes time and dedication to looking at analytical data. Buy a book, take a course, or hire someone, because there is so much involved in it. I spent a whole book on it, and you must be able to embrace the learning curve of online advertising. Another method is even easier:

Funnel No. 2: The giveaway model is a classic marketing approach that many online businesses use, and it can work particularly well for artists selling art.

This is how it works. Your goal is to convert as many followers as you have on Facebook, X, and Instagram into email contacts. Then you can sell your work to those contacts after creating a desire in them to own your art.

It begins by creating a giveaway, which in the case of visual artists likely means creating an inexpensive print of your art that you announce is being given away. You can decide what kind of print you are making.

You have many possibilities, like creating a print on aluminum or paper or canvas from any image that you have made. First you make a post on Facebook, X, or Instagram saying something like "Today I launch my new website, and I am going to give away a print of my art to celebrate! Just sign up if you want a chance to own a print of mine for free (including

shipping)." Then you provide a link to a page where visitors can fill in their name and email to be entered in a contest where one person wins a free print. All of the contact information that is voluntarily submitted for the contest gets added to your email list (this can be automated using a provider such as MailChimp) to be used at a later date.

This grows your email list and generates interest in your art. All of those who signed up for a free print now want your art—they hope they will win it. Then after seven or ten days (or however long the giveaway is), you announce the winner (on the same sites as before) with a photo and even a video if you can of the winner showing it off.

Now you have many new emails on your list of people who wanted to own that print for free but did not get it. You have created a desire for your work in all of those people that are now on your mailing list, even if it was just a dozen people at first. The next step is to email those people and tell them they can buy a print or other work of yours and you are offering them a 10-percent-off coupon for the next week (or the next three days). These people who wanted a print but didn't win a free one now have the chance to buy one, or another original artwork, from you at a discount.

Here is the summary of Funnel #2:

1. Launch a giveaway for a print.
2. To enter, individuals must enter their email address on a page with a sign-up form. You collect their email to build a list of people interested in your art.
3. Announce the giveaway winner.
4. Email the other people on your list with a discount code to buy something else from you.

That funnel set up a whole marketing process that will help you sell original art as well as prints. You have a mailing list that will grow because you will eventually announce a new giveaway, and new customers will come on board and new sales will be made as you follow up with these emails.

You could do a giveaway four times a year or more. I have given classes on just this model alone because there are many steps and plenty of ways

to get creative with this process, but the outline above should get you moving in the right direction and making sales.

For a website to manage sales that has e-commerce capabilities, I would strongly recommend squarespace.com for its elegance of design, its user ease, and its price. You can also use WordPress with a variety of plugins, but that tends to get complicated unless you are great with WordPress, so I would stick to a website that has simple templates, a blog page, and e-commerce tools that work well.

Alternatively, you could use something like Etsy, which will do retargeting for free for you as part of their listing price.

Your audience niche

Your audience is often more of a specific niche than you think. For example, if you were selling candles, you might think everyone needs candles, so your audience is everyone. But actually, age range, among other factors, will narrow it down. Children probably don't want candles, and the technologically obsessed may not want your candles. Survivalists might want them. For other people, it might depend on what's in the candles. If they are made of organic beeswax with no additives, for example, there is a specific audience that is concerned about indoor air quality and will be interested in a product that is less harmful to inhale.

If you're selling art, it may also seem like everyone can buy art, but there is an age demographic there, too. Perhaps there is an educational demographic as well, because buying art is a bit sophisticated on one level—to understand why something is beautiful and of value as an artwork is not an easy evaluation to make as a buyer. It often takes an education to understand art and to decide about buying it. You must have a form of "visual literacy." All of these are parameters you need to consider when deciding who your audience really is.

For the second element concerning how you will reach your audience, there is what is known as "targeting" an audience. Your audience may live in a certain part of the world, in certain major cities or away from major cities, or be doing certain online activities. In the examples I have discussed so far, I used survivalists and art collectors. Survivalists may not

be living near a city center, may have specific political affiliations, and would most likely be interested in going to specific websites or attending events and camps designed to support their interests. Art collectors also have habits that are similar in terms of what they might do and see and where they live.

The third element of the funnel—which is probably the element of greatest interest to you, or, at least, the part where success is measured—how do they actually buy from you and through what process? Are they using their credit card or PayPal? How easy or difficult is it for them to go through the steps it takes to purchase your product?

The final part of this is the shipping and handling. That may seem like the easy part, but it is where many small businesses get bogged down in spending too much time on the processing of orders, which can cut deeply into profits. Let's look at a few basic methods that many people use to start making sales without a funnel.

The well-known site eBay is a platform with built-in buyers. You can sell your new invention, product, or your art there. The process is fairly straightforward. On eBay, you can post images, a video to discuss your work, and of course, you have a few options in terms of selling. You can have a "Buy-It-Now" price, and you can also create an auction. The auction is an exciting format no matter what you are selling, because people feel like they might get a really good deal—and they might!

You can always have a reserve price, but if you sell some of your products or your art at a reduced rate, it gets people interested. And when several people don't get the item in an auction, it generates a desire to acquire something similar in the future.

Amazon is another very popular platform for selling products and testing the market, as well as selling art. Both sites require promotion to keep sales going, as well as reviews, but you can help that along by being very active on those sites.

For eBay, that means posting something every day. I do mean *every day*. You will build up an inventory this way, especially if you are an artist, and if something doesn't sell for the reserve price or higher, just keep relisting it.

On Amazon, you can keep adding more versions of your product, or you can keep adding more content by adding to the description and testimonials from previous buyers.

Meta and your sales funnel

Because we give so much information to Meta (owner of Facebook, Instagram, and Threads), it is an extraordinary place for advertisers. For the first time in history, it's relatively easy to choose very specific details about the demographic we want to reach, which is a big boon for advertisers.

12.

MORE INFORMATION ON ADVERTISING ONLINE

You may see offers from online marketers claiming they will teach you how to make a funnel without spending a dime. What that deceptive phrase actually means is that they will explain how to advertise online and get a good ROI (return on investment) so that, in the end, you make a profit as opposed to losing money.

You do actually have to spend money with advertising, but if you do it correctly, you will make a profit. Thus the deceptive phrase "without spending a dime" would be more accurate if it were "how to advertise and make a profit." But that doesn't sound as catchy, right? I mention this because almost everything you need to know will be explained in this little book. Even if you decide to have someone build the whole funnel for you, there is no need to spend thousands on that. You can hire people, though freelance sites like Upwork, to do this work for much less once you understand the architecture of it.

Advertising online and a "funnel" defined

Here is one way I advertise and create a "funnel" for new students. One of my businesses is teaching classes online, so my ads are of two types on Instagram. I have one ad that simply says, "Join my free newsletter subscription to get more resources for artists, like grant lists and other opportunities."

In this case, I am using something called a "lead ad," which means when a customer clicks on the link to "subscribe" to my newsletter, their email and name are already filled in, and they just move on to the next step, which confirms their subscription.

It is very simple and is one way to build your mailing list. The cost of getting people to sign up in my lead ads is about fifty cents per email obtained, more or less. This is inexpensive for a lead, meaning the person

who is signing up has a fairly high likelihood of being interested in your product and buying it in the future. The other ad type is called a "display ad"; this is usually an image with text or perhaps a video. Its main purpose is to pique the interest of potential customers and to provide a clickable link that will bring them to your website; it doesn't capture their email on the spot. In this chapter, I'll get into the details on both kinds of ads and how you can use them.

Making a "lead magnet"

Your audience is collectors, not other artists, so your lead ad for your funnel might be something like, "Interested in collecting art? Join my free email list, and I will show you how to collect art and build a collection that is valuable and beautiful." Then they click the link to subscribe, and they are on your mailing list.

How-to resource ads

You can also offer free download of a desirable set of instructions.
For health-related products, it could be "How to Care for Your Skin" or "How to Keep Fit with 10 Minutes of Exercise a Day." When they are on your mailing list, they'll get a download of a PDF that could be as little as two or three pages with illustrations to get them interested in what you are selling.

For artists, it could be a PDF download of "How to Collect Art and Build a Collection" or a book of your images.

Cost of ads

Consider the cost of obtaining emails. Do you have a low rate (under $1 each) or is it costing too much ($3 or more)? Some businesses may feel comfortable paying more for customers' email addresses because their product cost is higher.

For example, if you are selling luxury watches that start at $2,000, you just need one sale to justify spending $5 per name for the first 300 names. Using that as an example, if you spend $5 per email through an Instagram lead ad, and you make a $2,000 sale after spending $1,500 on 300 emails, you might be breaking even in terms of making a profit.

But remember, you also have 299 other names on that email list, and if one of them buys, you are way ahead, because you already paid for the ad with that one sale. The lead ad from Instagram is just one type of ad, and it is fairly simple, but you can also hire people to help you with these things. I will talk about that in a later chapter.

Display ads

The other type of ad that I run regularly on Facebook is the "display ad." This is the kind you see more often, with more text, often a video or image, and a link to be sent directly to a website or perhaps download a book. It is not designed to capture an email immediately and have the process end there like a lead ad. Instead, it is designed to get a potential customer to your website or perhaps a webinar. I use these types of ads even more than lead ads on Instagram.

Webinars

The display ad attracts potential customers, who are students for my courses, to a free online webinar. In that online webinar, I give a live talk about the information they are interested in. The talk I give is full of information they can actually use—not just partial information, but real usable information they can run with. Then I offer them a class at the end, in case they want personal attention and more support.

That is the format for most webinars these days: give real and useful information, answer questions from the audience during the webinar, and offer them more support. If you are selling a product, you can offer them the product at the end.

13.

MORE ON THE ARTIST STATEMENT

The artist statement (how to write it)

There is a problem with the very words "the artist statement" or variations of that. The syntax is bad, and it sounds awkward. That's because it is awkward. Unfortunately, applications for grants, residencies, galleries, and just about every other opportunity for artists out there asks for an "artist statement." Applications often guide you on what to answer, because their creators know how vague "artist statement" is. For example, the application might say, "In your statement, explain your motivations for your art," which is also pretty vague. Others might make its requirements sound more like a mini biography, a profile, or a narrative of your career. But that is a biographical piece of writing, not a "statement."

So what's going on?

There are numerous books, like the one you are reading, on professional development for artists in all stages of their careers. There is usually a chapter on "artist statements." In most of these books, they give you a formula to get your statement. The formula, more or less, is that you say something genuine, ideally a bit academic, like what you are researching, what experiments you are doing, or what questions you are asking.

The other formula (less academic) often mentioned in such books is that the statement describes the beauty you are sharing with the world, your message of love or hope that will explain your motivations for making art.

Then there are versions combining those two, or something completely different. After all, this is a vague piece of writing, and that gives you great license to do whatever you want with it.

I will make some suggestions, of course, on how to approach it, but I want to make clear that the idea itself of what an "artist statement" should be is not defined.

There is also the matter of different artist statements for different reasons as opposed to a universal artist statement.

One way to accommodate all the different requests you will get for artist statements is to approach each one like it is its own work of art—a short letter or text or poem that does say something, but in a very unconventional way. You are the creator and can make it as you wish. That approach, which is to literally write a new artist statement every time you are asked, is more time consuming; though possibly more helpful, it is more work.

The universal artist statement, one that might go on your website, and can work for almost all applications, is yet another form. This is what I believe is most commonly thought of when you hear "artist statement"—a two- or three-sentence statement that is something between a mini bio and an elevator pitch.

I know this is all confusing and annoying in more than one way. Who wants to figure out how to write and customize and choose one of these forms for an artist statement? Very few artists do, unless writing is part of their studio practice. So, before I go further, the question is first, how will you get this done? A new perspective?

I would suggest you experiment. Rather than choose any one of the numerous types of artist statements that I have discussed—of which you can find examples of all over the internet—make it easy on yourself and be true to your art and what you do or do not want to write. Break the rules, or send a simple biography of who you are and what you do and where you live in three sentences.

But don't make it boring! Don't write a statement that is boring. Write something with spark, if possible. Write something genuine, write something from the heart, or write a question you have or a poem, or a fragment of text, or leave it blank or write that you do not write artist statement because you are a visual artist!

I think that last suggestion is the most liberating. When an application asks for it, or even on your website and anywhere else an "artist statement" might appear, in place of that artist statement write exactly this: I do not write "statements" as I am a visual artist.

I think that makes it clear, and maybe we can change the world this way. If this goes viral and artists all over the world start writing on applications that they "do not write artists statements," a social movement could take place that will make curators and gallery owners and administrators think twice about why they ask artists for "statements." And perhaps like so many trends and social shifts, we can eliminate the need for the artist statement!

That is my position, but the reality is you might need one anyway, so this is how I would approach the artist statement.

1. Write in the first person. This is critical because—just as I am writing in the first person singular right now—it feels more personal. This is important because often a biography is confused with a statement, so it ends up in third person, which sounds distant and too formal. So, begin with the first person.

2. The length should be about 250 words or less. It is amazing how concise you can be. It is hard, but it can be done. Enlist the help of writer friends to make it brief and to the point. Two hundred fifty words is actually a bit long, that is the maximum, so if you can do it in about two sentences, that is even better. The reason brevity is so important is that you want to generate interest, not tell them the whole story. It is a bit like creating profiles on dating apps—you want to hint at why you might be an interesting artist to get to know.

3. Try to avoid "art speak" at all costs. "Art speak" means the use of overly academic terms and ideas, things that came to you from art school or a university BFA or MFA program. Typically in these programs, artwork is discussed in terms of current jargon, politics, and visual culture. It's a school, after all, so artists must write, and so they invent things to write about, from historical essays to "defending" their art when asked about it. You can see examples of this if you go to open studios at a college like Yale (end-of-semester open

studios are almost always open to the public). If you go to these open studios and ask the artists about their work, they will be quick to talk. They all have a type of elevator pitch that leans to the academic. But rather than try to "sell you" with a pitch, they are telling you about their ideas or how the work was made or a bit about themselves. But they do so very succinctly and with grace. It is an academic posture that much can be learned from.

However, there is much there to be avoided, because this is the very nature of the almost universally derided "art speak." When these artists get out of college and interact with galleries or with collectors who don't have MFAs, then the elevator pitch, so to speak, that the artist created no longer works, it sounds pretentious because it is out of synch. The collector is trying to learn about the artist, and so it usually has to be put in simpler terms. No room for academic fluff! The language must change to something more relatable, to something that is easy to understand, like a story. It can even be poetic somehow, but something to hold on to that can be thought about or talked about.

4. Clichés are also something to avoid, and it is easy to fall into them. One of the ways it happens is to talk about "why" you paint in generic or vague terms. For example, saying that you paint because you love to paint and share your joy with the world, or some form of that would be a cliché.

Avoid speaking of your art as though you are a messenger for the divine, which you are or may be, but putting it that way is common and may stop you from writing about what your art reflects.

Avoid overusing words like "beauty," "inspiration," "love," and "life". Cliché is repeating common terms. There are also common phrases such as, "I paint what I see," which are not that interesting. Or "My work is about meditation" (or some inner process) is also all too common.

5. Avoid writing statements at all costs. I know this sounds extreme, and I am of course a teacher who wants to see your artist statement work for you in applications and grants and galleries. However, I also want to see you suffer as little as possible. There is no need to torture yourself over this. In fact, I personally think it is a burden on artists and should be eliminated, but that is the last matter.

6. You can begin to avoid the statement by taking it off your website. It is likely not helping anyone, so (unless you really like it), remove it. Instead have a short biography in third person, the way author bios are written on the back flap of books. It should be short, succinct, just the facts. Where you were born, what you do, and often where you live, that's all.

 You can also avoid the statement by offering this bio I just mentioned for applications.

 Finally, you can avoid the statement in the most radical, world-changing way, as I mentioned prior to this list. When an application asks for it, or even on your website and anywhere else an "artist statement" appears, in place of that artist statement write exactly this: I do not write "statements" as I am a visual artist.

7. The last word on statements here is that you are in charge and can do whatever you want. You make the rules. We live in a changing world where instead of filling out forms and reading instructions, our engagement with exchanging information with other people is changing with technology. The arts will have to follow this model in some way. I think there will be fewer and fewer words from artists, because we seem to want more direct experiences, without mediators.

 In the future, perhaps the art audience will crave a different experience with art that is deeper, based on looking closely. That is "visual literacy" and what it takes for your audience to absorb or digest your art.

As an artist, you are in charge of this dialogue, this "visual literacy" training of your audience. Typically, that has been through a form like "artist statements," but we know that is limited and does not really give the viewer insight and a connection to your work. So, what creates that powerful reaction to your work? How will your audience get that from an image online?

These are questions that are not solved by an artist statement but at the core of what a statement tries to do. The answer is in your hands. How you talk about your art, or don't talk about your art, will be telling. Remember that as the artist and maker, you design the rules of what works for you and why you make art. You don't have to fit into a preexisting paradigm of any kind—you make the rules of creative process and engagement.

14.

MORE INFORMATION ON FINDING A MENTOR

My first mentor

In my first year of undergraduate art school, I met a friend there named Mark. He was an art student, and I hadn't chosen my major yet. He told me that he liked my drawings and that I should try to get a show in New York, and I should show the work to other well-known artists. At the time, I was not only very young, but I also didn't even have much work. I continued to listen to my new friend and watched the way he worked. After college, he was already working with some of the most popular painters that were exhibiting in New York City at the time.

I asked him how he met all these artists who were famous, and he told me they were all in public phone databases! He simply began calling them all up and asking them a question. The question he would ask depended on his situation. One question was if they would consider selling him a small drawing or something that he could pay for in installments, since he was a student. Think about that for a minute. A well-known artist gets a call from a very young artist, asking if he can buy something on a payment plan because he doesn't have much money. That is an unusual call that is quite flattering to the artist. Because even if that artist does not really need the sale, he or she also realizes that the person wanting to buy their art is more sincere than the average collector who is making an investment. Do you see the attraction? Even though the caller, my friend Mark, does not know the famous artist, the artist is impressed that someone without much money wants to buy his or her work.

What would typically happen next is that he would get invited to the artist's studio. That was nearly enough reward for him, because while he was there, Mark could talk to the artist, see the studio, and maybe even ask for a job. Did you need studio assistants? Can I buy that drawing scrap on the floor? The result of his efforts was to get a job as a studio assistant in

New York City and an incredible collection of art by major artists! That's right, Mark built an amazing collection this way. He bought all these works paying as little $25 a month to these major artists.

An art collection from mentors

Mark told me he would go to famous artists' studios and look for a very small drawing, even something on a scrap of paper or something that looked odd for some reason, and he would ask about buying it. The artist would either give him a payment plan, or in most situations, they actually gave him the work for free! They gave him the work because it seemed small, and they liked that Mark was so enthusiastic about it. In Mark's apartment, he framed all the works beautifully, and it was one of the most interesting collections of art that I have ever seen. Each piece was fascinating because at first it looked nothing like what you would expect from the well-known artist who made it. Upon closer inspection of the work, you might see traces of the style of the artist, but it had many surprises in it.

Mark was the person who made me realize that the world of art might work very differently than I previously thought. This is the person who shifted my perspective from not knowing to seeing a way into a world that I knew very little about and had no connections in. He taught me the importance of artists starting their own collections of other artists' work and building valuable relationships in the process.

This was of course very helpful, and today, if you are looking for a mentor and you haven't met a supportive friend like Mark, there are many online mentors now; I am one of them, of course!

Choose a mentor based on your personal feelings toward them (do you like their vibe, their attitude) as well as the information they are sharing.

15.

MORE INFORMATION ON RESIDENCIES FOR ARTISTS

Some artists tend to exhibit only in their own country, or very locally, and that is fine, of course. But the art world is an international dialogue—an international showcase. This is evidenced by biennials that now are held in almost every country, as well as art fairs like Art Basel that we see traveling the globe.

Here is a checklist for more international recognition and residencies.

1. Apply to nonprofit residencies, and you will get into some. Often the residency itself will pay for travel and living expenses and you will meet curators and artists there while you work on your own art in your own studio. This is an extremely important step for artists anywhere in the world. It is literally one of the most vibrant places of gathering for the international art community. You will see the language and the tone of the international conversation, and you will also see the people who can connect you to more residencies and even biennials. You can find opportunities using a website like rivet.es.

2. Visit international biennials online and in person, when possible, to see what art they are showing and how they talk about it. Keep track of what curators are putting on the shows, because if you relate to some of the work, these are curators you could pursue at a later time. If you can apply to the biennial in the future, then do so.

3. Apply for grants (if you want and need them) because when you receive an international grant, that fact alone travels in international circles and helps your recognition on a global scale.

4. Apply to nonprofit shows and even "artist-run" spaces because these spaces are not selling work, they are presenting it for educational purposes and this is often where commercial gallerists can "discover" you. (But never pay—no pay-to-play schemes, ever.)

5. Work with a good commercial gallery, because then your work can be sold to collectors who have other great work and it will boost your profile among collectors.

6. Take on commissions or other "commercial" work to support your career. Those are the main elements of getting international recognition, that is, the attention of the global art community of collectors and curators.

To clarify the reasons why noncommercial as well as commercial activity is very important, let me explain how they operate together. If you are in a biennial, say, and have a gallery, then the biennial will generate attention for you (not sales), while the gallery will probably have an increase of sales because you are in a biennial. Without the biennial, the gallery alone might sell your work, but not as much, and not to the global community.

The same applies to residencies. You will meet important curators at these residencies, and that in turn can lead to a commercial gallery representing and selling your work, because independent curators that are part of a residency usually also work with galleries.

Finally, this last "commercial" idea is to use your artistic abilities in service of another income stream. That could mean painting portraits, for example, or doing interior murals. I know an artist who supports an art career that is often politically charged in approach, and so her portraits generate an income stream so that she can keep pursuing her main studio work which often gets exhibited but does not sell as well, or at least not consistently.

If you are a photographer, you have many options for commercial work outside your practice and if you are a sculptor or filmmaker, again, you have the possibility of doing small, commissioned projects for people. Don't think for a moment this can hurt your other "studio practice" because, just like a teaching job, it will instead support it.

16.

MORE INFORMATION ON SELF-WORTH FOR ARTISTS

Confidence

When I first owned a gallery, I was visiting an artist's studio, which was a total mess of paint cans all over the floor and piles of work on paper. I wasn't sure where to look or what to say about the artist's work. Then she brought me over to a pile of drawings, many of which had newspaper pages sandwiched between them.

She began looking through them and then stopped without showing me the drawing and stepped back. The artist said to me, "Oh, this is a wonderful painting, [and in hushed tones] yes, this is really a great piece."

Then she carefully pulled out the drawing on paper with great reverence and turned it over as she herself seemed to be taken back at its beauty. The drawing, which I now own, was a large splotch of brown. It looked like brown paint was poured on the paper and ran off in small rivulets randomly, leaving a large brown spot and small drips running off the edge.

I had no idea what to say when I saw the drawing. I didn't think it was extraordinary at all and might have passed it by if I were looking at several works together. But the way the artist treated this work and the pride she had in showing it to me made me reconsider. After all, if she thinks it is so amazing, what is it that she does see in it? I was drawn in and looking for an answer, which I didn't find right away. Her ego and sense of self were charming in this scenario. Could you do that?

For the time being, I suggest you leave the question aside as to whether your art is worthy or good or exceptional—or if you are talented. There are numerous historical examples of artists whose work was not recognized until after their death, when it found its way into museums. Van Gogh is certainly one example, but there are many others, and what about the artists whose work didn't survive after the artist died?

Could there have been extraordinary artists that we have never heard of whose works have vanished? Absolutely. It is tragic, but it is also all too common. So rather than think about whether or not your work is good enough for a museum, concentrate on how you are presenting your work. The more time you spend in the studio making art, the more time you spend looking at your work, writing about it, and showing it to others, the more you will feel that you are getting better all the time and that your work as well as yourself are valuable and of quality.

Faking it / role play

Each action you take to get your work out there is another step to build your sense of worth about who you are and what you have to offer. Another way to look at the issue of confidence is to begin by faking it. We have all been to interviews or in situations where we were being evaluated, and we have gotten through it by acting as though we are calm and collected, even when we aren't. When you are asked in a job interview if you can handle the job and you have doubts about your abilities, what are you going to say? It can be the same with your artwork, only the situation is a bit trickier, because you made the work yourself and have a very personal relationship to it. Therefore, your approach has to be careful and planned. Say what you want your art to be, even if it is not there yet. You can talk about what your art is reaching for, what it means to you, and what its message is.

See also the last section of Appendix 10 on role-playing at a gallery.

New paradigm?

The New Paradigm is a call to action for all artists all over the world to change the current system of financial support for the arts, resist the global lean to the political right, and do what we can to prevent catastrophic climate change. Everywhere in the world, we see the seeds of revolution in protests asking for the right to be heard and fighting against government disinformation.

The world came together in sorrow and in solidarity during the 2020 pandemic, and this is a leading force for future generations and the rest of the 2020s; we are in this together. As artists, you are free to create new

structures, new ideas, and new ways of making a living from your art. Some of that may include selling your work or trading your artwork for services like medical bills and groceries or exhibiting in local libraries and coffee shops. But there are many more ways, some still to be invented by you.

As artists, there is collective power as well as individual power, and if a movement is created that supports artists, it will lift us all higher. Thus your support of your fellow artists helps the community of artists that you are immersed in. Support your fellow artists in this simple way: ask for studio visits, look at their work, and be supportive. Then ask them to come to your studio too—even if both your studios are your kitchen tables.

17.

MORE INFORMATION ON CONDUCTING STUDIO VISITS

Now there is the Zoom studio visit where a curator from anywhere in the world can visit your studio online, and almost in person. You can also make a presentation on PowerPoint or Prezi and share your computer screen during a virtual meeting. That works especially well for anyone showing videos or digital art.

We are talking here about building relationships in the art world. And step 1 is to go out and talk to people a bit, step 2 is to take a meeting with them, and step 3 is asking them something in that meeting. For this example, what you are asking for is a studio visit.

You can do this virtually now, as I said, but we will cover it both ways. A studio visit is special because it is so intimate. The viewer is investing a lot of time in coming to your studio and looking around. Also, for people who are not artists themselves, going to an artist's studio is a very unusual and even exotic adventure.

The key to getting a studio visit is to make the person you are asking feel comfortable with you. If you are just getting to know someone, asking them to come to your home or studio may seem a bit forward, even awkward. The easiest way to get around the awkwardness is to have a very small party. Invite up to seven people over, depending on the size of your studio. These people should have an interest in your art but should not be fellow artists or family. It's easier to invite someone to a small gathering like this at your studio. If you ask them this directly, they will answer directly. Be ready to have a day in mind, then get people there!

The way to have a party like this is to invite the right crowd, which again is just four to six people or so. People who are either fans of yours already, friends, or new people that are learning about you. You do not want this to turn into a party where people are drinking and talking and dancing. You should have wine and cheese there, but it is a very sober

event where you can talk about your work. That is a very important consideration when deciding how you will have a party or give a tour of your studio. The tone has to be very focused on your work.

Remember your goals when you are showing someone your work. You want to sell them one of your pieces, you want them to take an interest in you and the way you work, and you want them to come back again. You are a professional, and they should see that by the way you act. Keep the event to a two-hour window, preferably in the afternoon or early evening. Keep in mind that you want them to buy something, but in the first visit, just make them comfortable. If you have any press clippings or reviews of some kind or a book, have them all within reach somewhere in the studio.

The studio tour

Take your visitor around assuming that they are feeling a bit shy and are not sure what to say. In most cases, this is the fact; how would you feel in a studio where you do not know anyone and were being shown art? The way to break the ice easily is to tell a story about one of the pieces. This can be wide open, but it is an important talking point when someone visits the studio; telling a story can relax both you and the visitor. They are in a foreign place, so take them by the hand (not literally, but figuratively) and bring them to your work, or get them something to eat and then bring them over to a work and tell them a story.

It could be anything, but something authentic, something you can easily remember. You could talk about how you built the painting, your technique, and what was in your mind. Or you could talk about what was happening to you the day you started the artwork or the time in your life it was and the transition you were going through. Or you might talk about the narrative of the work itself, its message, so to speak. If there are things in your artwork that you can decode or explain for the viewer, they are more drawn in. Give them tools to feel comfortable by describing what you like about the painting and what works—or what doesn't work, even.

You are educating the viewer on the process of looking at art. Everyone loves this, no matter how sophisticated or amateur a viewer they are because they are learning, and that is a reward in itself. If you practice this

with different people, you will get better at telling a story and then involving the viewer in your story.

That is the next-to-last step in this process, and we are far into it now. You have met, written to, and finally gotten a studio visit from a curator or helpful person and they are in your studio.

The final step is telling them a story and becoming better at involving them in the story. For some this comes naturally, but for some it does not. After you pick a story and feel comfortable telling it, ask your viewer questions that can bring them in. No one wants to hear a lecture on your art, they want to relate to it, they want to feel that they have a personal connection to it. The only way they will get a personal connection is for you to help them make it. If at some point you are telling a story and it involves an encounter, you can ask, "Has that ever happened to you?" or something similar and get them to start talking about their experiences. Then at some point, bring it back to your work. Then do it again; ask them more questions so they would begin telling the story of the painting with you. Now you have a fan and an admirer.

Zoom and FaceTime

The same process is even easier to do with Zoom and FaceTime. I talk to curators throughout the world and all of them do studio visits virtually to supplement the physical visit or instead of that visit. Collectors are doing the same thing. It makes it easier for everyone and is now the default process just to make it more possible—and less awkward since they are not in your private studio space.

18.

MORE INFORMATION ON WRITING, HOW TO GET HELP WRITING, AND HOW TO APPROACH WRITING

Getting into the Whitney Biennial

Why is this "the story every artist wants to hear," as the curator said to us? ("Us" being my wife and myself as an art collaborative, Praxis.) Because when we were selected for the Whitney Biennial, we were not chosen or sought after. We were not "solicited" by the museum. We had no gallery representation. We simply sent them our materials and a letter and got into the show. It is like winning the lottery: as the saying goes, you have to play to win. We played, we wrote, we reached out, and of course you could, too.

Let's analyze the approach for a minute so it can be adapted to you and your medium. To begin with, it is important to keep up on who the latest curators are for the Whitney Museum or any other museum or gallery. I read the *New York Times* for some of that news, and also the Art Newspaper, which you can get online. It is essential to read and keep up on what is happening in the art world. Then once you have decided you know who you want to reach with your work, usually a curator, send them a letter. The letter is the tricky part. What will you say, and will you include a statement and a biography? Of course, it is up to you; sometimes a résumé is asked for or required, other times not. But remember you are writing a letter to a person, and that person wants to read something interesting.

You must decide what to say in the letter that will generate enough interest to have them look at your work. You can be as creative as you want. Send a poem, send a diatribe, a manifesto, a joke, or a very straight letter, it is up to you. Just remember the goal—to get the reader's attention and to have them open your images, look at them, and think you are an interesting person.

Writing to get a response

The format I use now, whenever writing a letter to a curator or someone that I want something from, is this:

1. The beginning of the letter should be a compliment (such as why a specific show they curated was truly good—be sincere and thoughtful here in two or three sentences).
2. The second part of the letter should say why your work has a connection to the shows they are mounting.
3. The third part of the letter should ask for what you want, like a virtual studio visit.

If you are a painter, sculptor, video artist, or conceptual artist, you have as good a chance as anyone, but you must present yourself in a way that makes sense and is attractive. The moral of this story is, "If you do not ask, you will probably not be invited."

19.

MORE INFORMATION ON THE ETIQUETTE OF PRESENTING TO MUSEUMS

All of these tactics are, in a way, about etiquette and manners—and how to approach and communicate with different people and institutions. Find more advice on etiquette toward patrons and sponsors in appendix 8. In this appendix we discuss approaching museums for exhibitions.

Presenting to museums

For museums, which are usually not-for-profit, what you are looking for is two things.

One, you want to know who the curators are. You want to know their names and what they have done in the past. It should be easy enough to find their names at the museum's website. If that is difficult, call the museum and ask who the curators are for contemporary work.

The other thing you would like to know from a museum is if they have a policy for looking at the work of new artists. You can write them a letter and simply ask. Now let's go to the next step of this situation. You have a list of the museum's curators, and you have a sense of the shows they have, and perhaps they do look at the work of new artists.

If they have a policy of looking at work, simply follow their rules. Usually they ask for a letter, images, and an artist biography. Keep in mind that most museums that have policies of looking at artists' work are usually not exhibiting those artists right away. Plan one to three years in advance.

What museum curators often do is look at work so that they can understand more about what is going on in contemporary art. Also, even if they like your work very much, they will want to see more before committing themselves, in most instances.

Normally you will get a letter back from the museum curator stating something like, "Thank you, please send us an update in six months."

This is so they can see how your work evolves and also if you are professional enough to keep sending them work on a regular basis.

The next step with museums, which you can do at any time in your career, is to target a specific curator. In my experience, it is easiest and best not to target the top curator. Look for a new curator, someone who is probably young and handles something that might not even apply to you, like booking performances or music. Write to that curator directly and ask him or her if you could meet with them to talk about a project that you would like their feedback on. I always ask if I can meet the curator for a ten-minute Zoom meeting. Usually that is hard to say no to.

It is also helpful if you Google the curator and find out something about them to reference, showing that you know who they are!

Preparing for a meeting

The idea is to get a meeting with a curator, any curator, and then prepare yourself for the virtual or in-person curator meeting in the following ways:

1. If in person, bring printed images—not a laptop with pictures on it, but printed images—preferably fewer than ten, on eight-by-ten (or a similar size) sheets of glossy paper. They can be printouts from your home printer, but keep everything very neat and organized. Do not bring original work or anything that is awkward. The idea of this meeting isn't to evaluate you or your art, but to make a proposal. If you are doing it through Zoom or FaceTime, you could make a slideshow presentation of your art that is no more than five minutes long (so you can discuss it), or you could use your phone camera to show them your actual studio.

2. Decide what you are going to ask the curator. Yes, you are going to ask them a question, because if you don't ask them something, you will have a pleasant meeting that will end with the curator saying, "Thank you and let's keep in

touch," and you do not want that! You want something more valuable from the curator, which is a reference. But what will you ask? What will you propose?

3. This is the fun and creative part. It depends on your medium, of course, but think about how you would like a show of your work to look. How many pieces would you put in that show? Will the show have a message? Is that message political, personal, spiritual, or something else? When talking to a curator, it is easiest to discuss ideas, because quite honestly, talking about art is difficult. It is usually difficult for the artist as well as for the person viewing the art, so talk about ideas, or other things you are interested in, from books to movies or philosophy.

Your ideas

Make your idea succinct and understandable. Perhaps you are telling them you want to have a show of paintings or sculpture or something else. Say exactly how the show would be put together and why it will be exciting. Tell them why you think the show is important. You should be able to say all that in less than one minute. Then wait for the curator to respond with something like, "Oh, that is interesting."

Then tell them that you want to present this show, and ask them if they know of any venues that might be appropriate for it. Wait for an answer; do not jump in with nervous talking. This method gets the curator off the hook from having to talk about their museum, and most likely there is little they can do for you there. However, they know other people that may be able to help you, and they might say something like, "Oh, you should talk to X, that gallery might like it, and also Y, because that is a space that encourages dialogue." Or they might even say, "So-and-so at this museum might be interested." Whatever their answer is, explore it a little, ask more questions, and take notes! Then thank them and leave.

When you get home, or end the virtual call, write them a brief thank you note. That is the way I got a solo show at the Whitney Museum. I made an appointment with a curator I did not know. I described three ideas to

the curator, and she told me two places for the first two, and for the third, she suggested another curator at the museum! It is really that simple if you just schedule the meeting.

We are all interested in ideas, and especially when the person talking about the idea is enthusiastic and positive. When I talk about ideas to a curator, I am very excited about it, like I was as a child when it was easier to express enthusiasm. People are very attracted to others who are sincerely excited and happy about a creative project; it is the life force we all desire and live for.

We have covered how to present your work to a museum, either for review (if they have a policy for that), or by talking to a curator about your ideas. Presenting your work in these cases is fairly straightforward, with the exception of talking to a curator, which is more creative and personal.

Your ideas for the work you have could be a small show of four paintings, or videos, or photos, then a larger show of perhaps two mediums (paintings and video or music and drawings, etc.), and then the third option, a large solo show of something more comprehensive that has a particular message.

Gallery presentations vs. museum presentations

Galleries are very different from museums in two ways. One, their motive is profit. If they don't sell, they are out of business. Two, they are privately owned, so there are no strict rules or standards that apply to all galleries. You are approaching a business owner who has certain goals. One may be to show great art, but the most important thing to them is making money to pay their bills.

For a short time, I helped a musician friend get booked at clubs in New York City. This is what I learned: if you have a band and want to be booked at a club, bar, or venue of some kind, you have to convince the owners of the venue that you can bring in a crowd. That is all, and you are booked. Sounds simple, doesn't it? It is all about the money.

When people go to see bands, they drink at the bar, and that is how money is made there. So if I can just guarantee one hundred people will come, I can have almost any night at any club. Amazing, isn't it? It is all

about the money and not necessarily the music at all! The key is obviously how to bring a crowd in. That comes from great self-promotion with stickers, Facebook, YouTube, Bandcamp, giving away and selling merch on the street and online, free downloads and more. I know one band that packed the house by telling every one of their friends they would supply free beer to everyone after the show! I mention this because it is not dissimilar in the gallery world.

Many gallery owners want to turn a profit and are not afraid to talk about money. You may wonder, "Is the quality of your work important to them?"

Yes and no.

Like the story I told about booking bands, if they feel you can bring in a buying crowd, they are interested. A friend of mine, who is a private banker and works with some of the wealthiest individuals in the world, told me, "You have to think, 'what does the person that you are trying to reach want?'"

In the case of a gallery owner, what they want is to make a profit and bring in more collectors. They have a list of the collectors who have bought from them in the past, and they are always trying to grow that list. If they do not increase that list, they are asking the same people over and over, and that is a limited situation, financially.

So in your approach, which I will outline here, it is much more than just sending or showing them images; you can do this even if they are a largely private gallery that sells work remotely. You can certainly send in images, but you must understand how the mind and eyes of the gallery director work. He or she is not only trying to decide if they like your work, but, more importantly, if they can easily sell this work and if it will bring in more collectors. Of course, if you are well known and trying to switch galleries, they are interested because you have made money for gallerists in the past. If you are not well known, then you are like hundreds of others who write to them, and if you try to look at it from their perspective, why should they show your work?

An offer they can't refuse

This leads us to the current trend in artist-driven marketing, which is making the dealer an offer they cannot refuse. That means making a proposal to a dealer that makes financial and aesthetic sense. This approach was created as much by the rising costs of running a gallery as by the competition among artists to get into a gallery. This means that the traditional approach of sending them your images online is not the best way to make a deal with a gallerist. To begin with, go back to your list of galleries in your area, research them online, and visit them in person when possible. Try to attend at least one opening, go to the all the Zoom tours they have. Take a look around at the opening or Zoom tour; do you like what you see? Ask questions about the work, and someone from the gallery will tell you more about it. Do you like the way they talk about art and sell it? If so, this is a reason to want to work with this gallery. If not, then move on or try another opening there to give the gallery another chance.

In the smallest galleries, your approach could be simple.

Walk into the gallery and ask the person behind the desk if they look at the work of new artists. They will give you their answer, which, if yes, usually means either sending them images by email or a studio visit from the gallerist.

If the gallery is more established, then making an offer they can't refuse will have a chance of working. But how do you make such a deal?

In this area, you can be as creative as you like, but it is a business proposal. Some form of "I have a great opportunity for you that could be a win-win situation for both of us," and then explain your idea, which involves sales, the press, and new collectors.

Here is an unusual example that worked well. An artist named Andrea Fraser does what she calls "institutional critique," which means that much of her artwork, which is sculpture, prints, and performances, critiquing the institutions of the art world, such as galleries and museums. Her proposal to a major gallery went something like this: She proposed a show in the summer (typically a downtime for galleries) for a month. The show was simple to put up; it was just a monitor in one corner, playing a video over and over. The video was of the artist having sex with a collector. It

was shot from a security-type camera attached to the ceiling of a hotel bedroom. It took place in real time without any close-ups. The video was in an edition of ten. However, the first collector who bought the video also acts in it. Thus, she is having sex with a collector. So for the show to work, one video has to be sold at $10,000 before the show opens. For the gallery, they have already broken even before the show opens! From the artist's point of view, she is creating a situation that, to her, exposes elements of the art world, that is, artist as prostitute, gallerist as pimp, and collector as john. But for the rest of the world, the public gallery audience, and the press, it had a different effect. They were shocked, aghast, and fascinated. That is one model of making the dealer an offer he can't refuse.

That particular show did very well and got Fraser tons of local, national, and international press. Now, you might be thinking you do not want to do that! However, your approach can be more subtle. Imagine telling a dealer you will have a show of your paintings, and there will be a band there, or a comedian or a magician. There will be different parties on other nights for select groups of people, such as a museum's young collectors' club or other associations that are interested in the arts.

That is just a sketch of an idea, but you get the basic concept. Come up with a deal that is exciting and impossible to refuse and generates a new audience. Even if your idea doesn't work the first time, you will get a gallery owner's attention with this kind of approach, and they may negotiate and brainstorm with you. A virtual opening on Zoom, for example, could be approached by having a panel of speakers that collectors want to hear from, like art historians or other collectors. Museums in post-pandemic culture are saying they have a greater attendance to their public lectures than before the pandemic because it is so much easier to virtually attend an artist talk or panel discussion. So consider putting something like that together.

20.

MORE INFORMATION ON INTERNATIONAL RESOURCES

The global art community

If you are living in many countries, there is usually something like an "office of contemporary arts," which is funded by the ministry of culture or similar.

Wherever you are, you are putting together a list of everything in your area that is art-related, meaning galleries, museums, and nonprofit centers. The nonprofit centers are places of education, usually. That means they are supported by the government because their goal is not to profit; it is to help artists in some way. Nonprofits, or in Europe, NGOs, are everything from community centers to granting agencies to foundations that have been set up to give money to artists; museums and universities also could be part of it.

After you have made the list of art-related institutions and galleries within your area, begin to sort them by which ones are closest. So pick all the places that are near to you and refine your list. Separate the types of organizations you are listing in different categories, such as galleries, universities, museums, nonprofits, art-related NGOs, and foundations for grants. Now you have a list of places and people to meet.

Take it one step at a time and begin by deciding how many you are going to call and visit in a week. I would pick a low number, like two or three in a week to start.

Pick a time of day that you can spend thirty minutes on this task.

The next step is to look at your three contacts for the week and do a little research on each so you can understand more about what they can do for you.

Ideally, you can do enough research that you know who the staff is at each of the places you are calling.

Then give them a call or write them a letter. You are not sending them links or images of your work; you are writing them a letter to ask about their services.

If they provide grants, you want to be on their mailing list and know when the next application is due.

If you are writing to a university gallery, you want to know who curates their gallery and who you can send a proposal to for having a show there.

If you are writing to an organization that supports the arts in some way, like an arts council or NGO, then you want to be on their mailing list, and you want to know if there are any opportunities you should be aware of, like competitions or grants or juried shows.

If you are writing to a museum, then you want to be on their mailing list as well, and you want to know if they look at the work of new artists.

International artists

Almost all the resources mentioned in this book apply to artists in any country. Because of the online presence of nonprofit organizations, non-governmental organizations (NGOs), artist-run spaces, Kunsthalles, and museums all over the globe, anyone who has access to a computer or phone can use resources that will offer them more exposure and awards.

The "art biennial" is the international form of large-scale exhibition that is designed for artists to participate in from any country in the world. But more importantly, no matter where you live, there are people around that can help in some way.

That is a universal concept: how to make a friend, and how to allow that relationship to grow personally and professionally. In all walks of life and in any town, the issue of how we befriend people and make good business and social contacts is essential because it also defines who we are and how we present ourselves. One of the guiding principles that runs through this book is how to be direct and polite in making new relationships. And that idea can be used in any city or town in the world, provided there are people there!

21.

MORE INFORMATION ON PRICING YOUR ART

Pricing artwork can be a challenging task for visual artists, as it involves a combination of artistic intuition, market research, and business acumen. Here are some key factors to consider when determining how to price your art:

1. **Artistic Experience and Reputation:** Your level of experience and reputation in the art world can influence your pricing. Artists with a strong track record, exhibitions, awards, and recognition might be able to command higher prices than emerging artists.

2. **Size and Medium:** The size and medium of your artwork can significantly impact its price. Larger pieces generally command higher prices due to the increased materials and labor involved. Additionally, certain mediums like oil paintings or sculptures often have higher perceived value than works on paper.

3. **Complexity and Detail:** Intricate and detailed artworks usually require more time and skill, which can justify a higher price. Complex compositions or pieces that require a lot of technical skill tend to be priced higher than simpler works.

4. **Time and Effort:** Consider the amount of time and effort you've invested in creating the artwork. This includes not just the time spent physically creating the piece, but also the mental and emotional investment in developing the concept.

5. **Cost of Materials:** Calculate the cost of all the materials used in creating the artwork, including canvases, paints,

brushes, frames, and any other supplies. This forms the baseline of your pricing.

6. **Overhead Costs:** Factor in indirect costs such as studio rent, utilities, marketing expenses, and any other overhead costs associated with creating and promoting your art.

7. **Artistic Vision and Uniqueness:** The uniqueness of your artistic style and the originality of your concept can contribute to higher pricing. Art collectors often seek out pieces that offer a fresh perspective or a unique interpretation.

8. **Comparable Works in the Market:** Research similar artists working in your medium and style. Study their pricing structures and compare your work to theirs. This can give you a better idea of where your art fits in the market.

9. **Market Demand:** Understand the demand for your type of art in your target market. If there's a high demand for your style, you might be able to set your prices slightly higher.

 Maintain consistency in your pricing strategy to avoid confusing collectors or buyers. Drastic price fluctuations can undermine your credibility as an artist.

10. **Gallery Commission:** If you're working with galleries to sell your art, keep in mind that they usually take a commission (often around 40–50 percent) from the sale price. Account for this when setting your initial price.

11. **Testing and Adjusting:** Don't be afraid to test different price points and observe how your audience responds. If your art consistently sells quickly or receives positive feedback at a particular price range, you might consider adjusting your prices accordingly.

12. **Emotional Value:** Art often carries emotional value for both the artist and the buyer. While it's essential to consider the practical factors, remember that some collectors are willing to pay a premium for art that resonates deeply with them.

Pricing your art is a delicate balance between valuing your work appropriately and making it accessible to potential buyers. Regularly evaluating and adjusting your pricing strategy based on market trends, your artistic development, and feedback can help you find the right balance over time.

22.

MORE INFORMATION ON SELF-ESTEEM AND SELF-WORTH

This is a motivational book, I hope, and that is partially my intent, but the motivational part is also the by-product of techniques that work coupled with my own sense of enthusiasm.

It all boils down to your intent.

It is enthusiasm that is being roused by a good motivational text; it is your own sense of power and your ability to change and create. Whenever you speak enthusiastically about what you are doing or who you are, it is magnetic. People are drawn to others who are excited about something. It can be very serious, or even dark or political, but you can still have enthusiasm about it.

And since we all want to be happier or more joyous in some respect, enthusiasm is one of the things we can look forward to. And it is something we can create.

Confidence

The role of confidence in your artmaking is one of the cornerstones of being a professional. If you can't find a way to become confident about what you do, it will translate that way to the buying public.

To take control of your self-confidence and sense of worth as an artist, the following are a few steps to take. The first step to take, or acknowledge, is that you have something to say and a desire to share your work with the world.

Ask yourself, "Do I have something worth sharing?"

Think carefully about your answer. Perhaps you are not sure, or maybe you do think you might have something worth sharing. Take your time with this question, because if you look over all the reasons to be an artist, one of them is surely that you have something to offer the world that is yours alone and worth sharing.

Step two is to get shows, even online ones. Often when I am working with artists directly, this is the biggest issue. Confidence is often something that is built up slowly and deliberately. One woman I worked with didn't show her work for almost ten years. She was in her sixties and trying to sell work again.

To build her confidence, she began applying to juried shows that you will see on lists like artdeadlines.com. They are not too difficult to get into, often cost a little money to enter, and may not be the best shows, but for some artists, they build confidence because they will be accepted into many of them.

Then she went to the local council on the arts and found out about other shows in her area that were juried and began applying to all of them. Soon she got into a local show, at a nonprofit center for the arts and a library. It did not seem like a big show, but it built her confidence, and she was able to move on.

Step three is to present yourself—through FaceTime or Zoom or in person—and display the confidence you have. How you communicate what you do and what kind of work you do is of the utmost importance. Can you answer those question quickly? Answering that question quickly and with a sense of enthusiasm will build confidence. It doesn't take much practice to get started.

External judgments

Often, artists want to hear from someone else that they are talented or that their art is of value.

This is almost like asking someone, "Am I attractive?" It is awkward and very subjective. If we take the example of wanting to know if you are an attractive person or not, it will help to understand this difficult question. What makes a person attractive? Besides the cultural implications of where you live and what the standards for beauty are in your community, there are several factors that can make you attractive.

Initially, there is how you physically look and dress. That is what people first see, and it makes an impression. If you use an online dating service, you can usually see a picture of the person that tells a bit about who

they are. However, the description of who they are and what they like is essential, so if we like the image slightly, we read the description of the person we are considering dating.

On a dating app like Tinder, we make those decisions rapid-fire in a just a few seconds. The Tinder description is akin to an artist statement or the artist's story. After looking at a person's picture, we read about their interests, and either we want to know more, or we do not. That means how people describe themselves plays an important role in what we think of them. In fact, in the example of online dating, it makes all the difference.

With art, it is not so different. You want to know if your art is good or not, and perhaps beyond that, you wonder if your art has a place in the historical timeline of art. That is, is it great? To begin with, how you present yourself and your art will make all the difference. If you perceive yourself as a professional and your art as potentially unworthy, and act that way, you will be treated accordingly.

Unfortunately, it is not solely based on your art, because everyone needs to know more, just like dating, but the art is what people react to first. This is where an artist statement comes in, or some kind of text that helps people to understand your work. That means being able to not just describe what it is you are doing, but also to make your text engaging and interesting, maybe even humorous. Again, the dating analogy holds, because you do not want to write a boring description of who you are; you want to say something that will pique the reader's interest right away, literally in the first few seconds.

23.

MORE INFORMATION ON THE ART ECOSYSTEM

Art world terms and definitions for those new to the art world or those curious about the terms we hear all the time.

What is the art "ecosystem" that collectors and gallery owners speak of?

The art ecosystem is generally understood to be ten elements that make the global art world what it is today. These elements include 1. The Art Gallery, 2. The Art Collector, 3. The Art Consultant, 4. The Art Fair, 5. The Art Residency, 6. Nonprofit Institutions, 7. The Curator, 8. The Critic, 9. The Biennial; and 10. The Museum.

In the following pages I will explain those terms. However, if you can imagine being familiar with all those terms and building relationships with all those entities, then you are indeed at the center of the art world. Here is the breakdown of the art ecosystem terms.

1. The Art Gallery

The art gallery is a space that is run for profit and the profit structure works this way: Artists show their work on consignment and typically get 50 percent of the sale price. That means if the work sells for 1,000 dollars, the gallery keeps 50 percent and the artist gets 500 dollars, more or less, plus taxes.

That is the financial arrangement between gallery and artist. There should always be a contract between the artist and the gallery explaining what art is being held by the gallery (on consignment), and that contract should also outline terms of a sale and when and how the artist gets paid.

Artists do not pay to be in a gallery. The financial arrangement is fifty-fifty, as stated above, and that is how the gallery makes money. Art galleries that charge artists a fee to exhibit are not part of the art ecosystem; they are "pay to play" galleries that rarely sell art (because they make their

profit with fees charged to the artist). Thus, the rest of the art ecosystem is not interested in those galleries because they select art based on which artists pay them.

Art galleries are all different. They are not regulated by government in any way (though some governments offer tax incentives for art purchases), so you can expect a different way of working with every gallery. Anyone can open a gallery if they have a space. Any one gallery owner can set their own terms for artists, but the gallery that is a respected part of the art ecosystem is the one that is aware of the rest of the ecosystem, participates in art fairs, and is aware of the global market and what is being sold.

It is also important to note that as an artist, you can introduce yourself to a gallery. If your work is in a gallery, you can talk to the gallery owner or director in very clear, honest, business terms. They should be interested in selling your work, and the more you can be part of that process, the better for both artist and gallery.

2. The Art Collector

The art collector is an important part of the art world because they are the main buyers of the art that is sold. Collectors come in different types, from those who simply buy what they like until their walls are full, to those who buy largely for investment purposes and have art on their walls and in storage units. Collectors that buy for investment and personal interest are well aware of the parts of the art ecosystem that I am listing and defining here. For example, collectors cultivate relationships with galleries and museums so that they can buy from galleries and also loan or give pieces from their collection to museums. Collectors sometimes start art residencies of their own or work with art consultants.

3. The Art Consultant

The art consultant is a term that can have many definitions, from an individual or team that buys art for hotels and corporations to those who personally help art collectors to curate and build art collections. Almost every serious art collector works with a consultant who helps them buy and manage their collection. That means the consultant is aware of the

collector's taste and current art collection, and their job is to help the collector buy more art that fits their needs and interests. Therefore, art consultants help collectors who are looking to invest as well as just build their personal art collections. At big art fairs, like Art Basel Miami, preview days allow art consultants and their wealthy clients (collectors) into the fair before it is open to the public to purchase work. Typically, consultants work directly with galleries when buying art, though some buy directly from the artist.

4. The Art Fair

The art fair is essentially a gathering of galleries that converge in one arena with their own display booths for the art they want to show. The biggest art fairs, like Art Basel and the Armory Show, can sell millions of dollars' worth of art. They take place all over the world, and collectors come from everywhere to attend and buy. The only way to get into these fairs is to have a gallery that represents you and takes your art to the fair.

You can also pay to attend smaller art fairs that charge individual artists for booths. There are typically fewer collectors at those fairs and the prices are much lower. The big fairs I mentioned are the ones that get written about in art magazines and can increase the value of an artist's work though sales there.

5. The Art Residency

The art residency is like a working trip. Residencies are sometimes started by collectors and are run as nonprofit entities in most cases. The goal of a residency is to give artist time and room to create in a new environment and to meet fellow artists. Typically, residencies are fully funded so that the artist pays little or nothing and receives free room, board, and related expenses. Art residencies can be applied to directly by artists. If you apply to enough of them you will get accepted to one, and as soon as you do one you will get more. It is a great way to meet other artists, have time to work, and meet curators. There are many sites to research and apply to them, but I like Res Atris (resartis.org), which is a worldwide network of arts residencies.

6. Nonprofit Institutions

Nonprofit institutions in the art ecosystem range from residencies and museums to artist-run spaces, nonprofit galleries, and government-related buildings that exhibit art, like embassies worldwide. These institutions play a special role because they encourage education instead of trying to make a profit. Because of that they often get the respect and attention of galleries and collectors and others in the art world who are looking for artists. As an artist, it is simply a fun and productive thing to do that will help you build a community of artists and curators around your work.

7. The Curator

The curator is a person who might be in a position to help you, depending on their specific job. There is the museum curator, who in Europe is a civil servant (a government employee) but in the United States is typically either working for a public or private museum or independently as a free-lance curator. The museum curator selects artists to be exhibited or creates shows from the museum's collection. A museum curator occasionally works with new, living artists like yourself, so being in conversation with them can be beneficial. Independent curators, who work for anyone from a private art collector to a gallery or nonprofit, often pitch shows that they think will have an impact and be exciting in some way. This type of curator has more flexibility and can also be helpful to befriend. Art collectors tend to know both types of curators.

8. The Critic

The critic is the person who writes reviews about art in major art journals, as well as in more mainstream magazines and newspapers. In the past, a good review from a known critic could increase the value of an artist's work. That no longer seems to be the universal case, for reasons I do not know. It may be because of the sheer amount of writing on art online or that the art ecosystem, as much as they like critics to teach them about art history, seems to thrive just as well without the approval of critics. Nevertheless, their job is and always has been to review art and help the public understand art that may at first seems difficult. Knowing a critic

can be helpful, especially if they can write a review of your work or the introduction to a catalog of your art. Most critics are available for hire— meaning they will consider writing a 1,500-word essay about your art for a catalog for a fee.

9. The Biennial

The Biennial is an art show that is global in its reach and perhaps one of the most prestigious venues in the world. The Venice Biennale in Venice, Italy, is the most famous. It's like a world's fair for art, with many countries exhibiting their best living contemporary artists. There are now well over two hundred biennial exhibits around the world. These biennials are often specific to one country or even one museum. They are often organized by a group of independent curators who come up with a theme of some kind. To immerse yourself with this world, look up The Biennial Foundation and find one near you. You can even send in an application to apply directly to some biennials.

10. The Museum

The Museum is an important part of the art ecosystem because it confers validation and value on art, and it teaches the public what art is for and what it is about. Working with museums is important for artists because they can increase visibility of your art and because it is prestigious. A museum typically has two major departments: curatorial and educational. The curatorial department is in charge of creating the exhibits and hanging the art on the walls, more or less. The educational department creates public events like artist talks, workshops, and panel discussions. You can check with your local museum to see if they have open calls for artists in the curatorial department. You can also propose education workshops to the museum (which can be a paid gig if they like your workshop). Being in either department is helpful to your career as an artist.

The Trifecta

Achieving the trifecta can help an artist a great deal. That means you have three of the elements above at once (same time, roughly, in the same city),

so that you get maximum attention on your art. The ideal trifecta: 1. A good gallery (not a pay-to-play space) that is having a solo show of your art. 2. Another exhibit in a nonprofit institution. 3. An exhibit in a public space, like a billboard or a park.

The public exhibit and the nonprofit exhibit will drive interest and sales to the gallery exhibit. This is a pattern seen in most major cities. If you want the biggest splash and the most attention for your art (as well as sales), then the trifecta is your goal—no matter where you are in the world.

A Final Note

Thank you for reading this book and for being an artist. You are a producer of culture and are changing the world one creation at a time. I applaud you!

If you want to keep in touch or take my classes, find me on instagram @praxiscenterforlearning or go to my blog (blog.praxiscenterforaesthetics .com) to find more resources and help.

I wish you a life full of art making and beauty.

About the Author

Brainard Carey is an artist and frequent lecturer on professional development for artists. He is the director of Praxis Center for Aesthetics, an online career development and support center for artists that provides educational materials as well as a community for artists and regularly brings in experts to talk about a variety of issues crucial to the development of an artist. Praxis Center also has ongoing lists of artist resources, including grants, exhibition opportunities, and more. As a working artist, he collaborates with his wife Delia Carey under the name Praxis; their work has been exhibited in the Whitney Museum of American Art, MoMA, and other venues around the world. He has interviewed over 1,900 artists and curators for his podcast series on Yale University radio, which is the source for much of the knowledge in his books. He has written seven books for artists and also has coauthored books with Delia Carey, who is a cofounder and codirector of Praxis Center. He is on the faculty at the School of Visual Arts in New York City, where he lives with his wife and son.

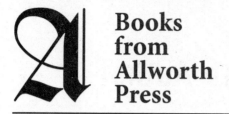

Books from Allworth Press

Allworth Press is an imprint of Skyhorse Publishing, Inc. Selected titles are listed below.

Aphorisms for Artists: 100 Ways Toward Better Art
by *Walter Darby Bannard & Franklin Einspruch* (5½ × 8½, 240 pages, paperback, $16.99)

Art Without Compromise
by *Wendy Richmond* (6 × 9, 256 pages, paperback, $24.95)

The Artist-Gallery Partnership, Third Edition
by *Tad Crawford & Susan Mellon* (6 × 9, 216 pages, paperback, $19.95)

Artist's Guide to Public Art: How to Find and Win Commissions (Second Edition)
by *Lynn Basa* (6 × 9, 240 pages, paperback, $19.99)

Business and Legal Forms for Fine Artists, Third Edition
by *Tad Crawford* (8½ × 11, 160 pages, paperback, $24.95)

The Business of Being an Artist, Sixth Edition
by *Daniel Grant* (6 × 9, 288 pages, paperback, $19.99)

How to Survive and Prosper as an Artist: Selling Yourself without Selling Your Soul (Seventh Edition)
by *Caroll Michels* (5½ × 8, 368 pages, paperback, $24.99)

The Joy of Art: How to Look At, Appreciate, and Talk about Art
by *Carolyn Schlam* (8 × 10, 280 pages, hardcover, $50.00)

Learning by Heart
by *Corita Kent & Jan Steward* (7 × 9.125, 232 pages, paperback, $17.99)

Legal Guide for the Visual Artist, Sixth Edition
by *Tad Crawford* (8½ × 11, 336 pages, paperback, $35.00)

Making It in the Art World, Second Edition
by *Brainard Carey* (6 × 9, 240 pages, paperback, $19.99)

The Profitable Artist
by *Artspire* (6 × 9, 288 pages, paperback, $24.99)

Sell Online Like a Creative Genius: A Guide for Artists, Entrepreneurs, Inventors, and Kindred Spirits
by *Brainard Carey* (6 × 6, 160 pages, paperback, $12.99)

Selling Art Without Galleries: Toward Making a Living From Your Art
by *Daniel Grant* (6 × 9, 256 pages, paperback, $19.99)

Starting Your Career as an Artist, Third Edition
by *Angie Wojak & Stacy Miller* (6 × 9, 336 pages, paperback, $24.99)

To see our complete catalog or to order online, please visit *www.allworth.com.*